STRESS-MELTING
MANDALAS
65 DESIGNS FOR ADULTS TO COLOR
Volume 2

Copyright © 2016 by Twin Bulls Media and Daniel Davidson.
All rights reserved. No part of this book may be reproduced in any fashion
without written permission from the publisher.

ISBN-13:
978-1537411460

ISBN-10:
1537411462

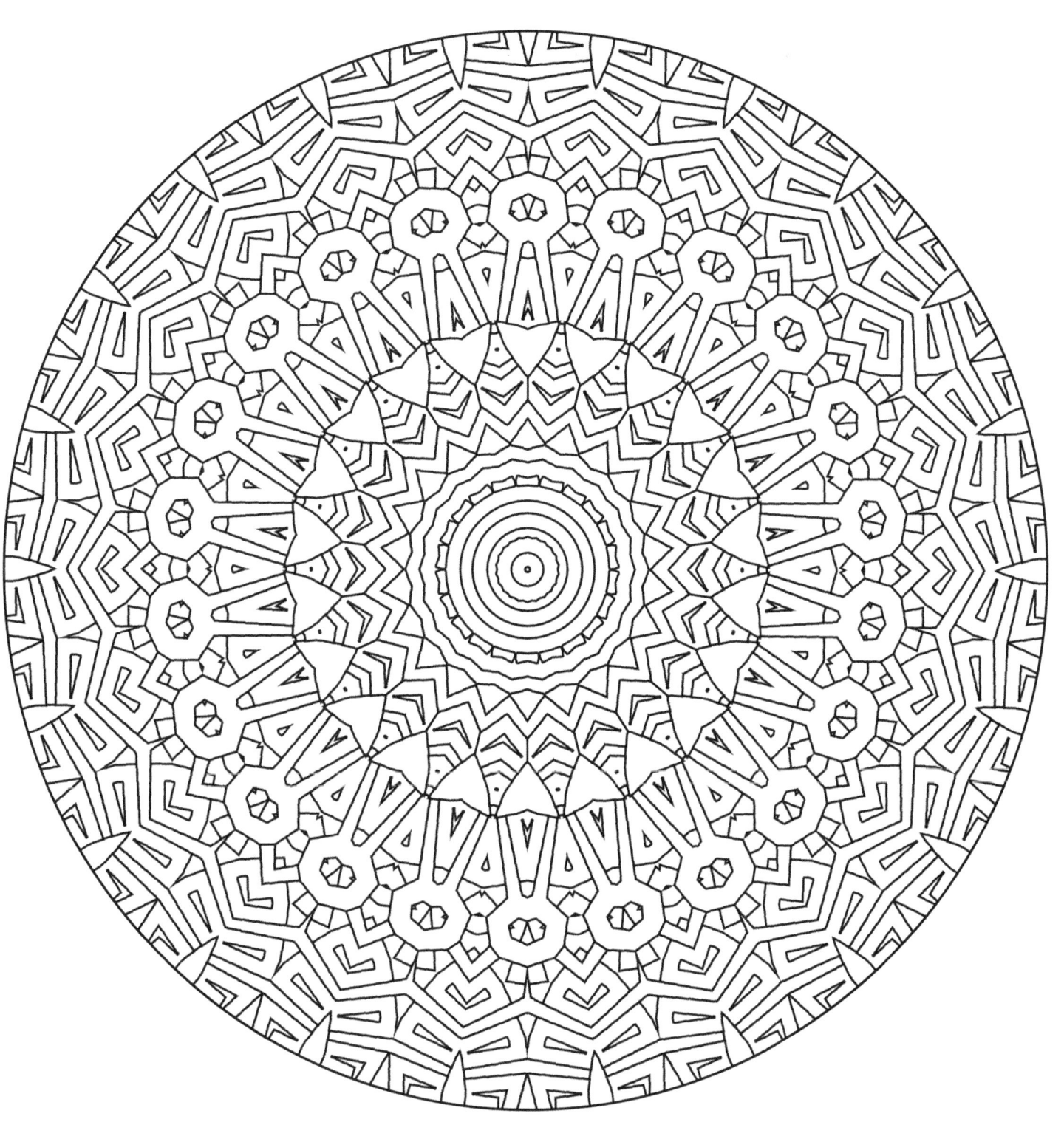

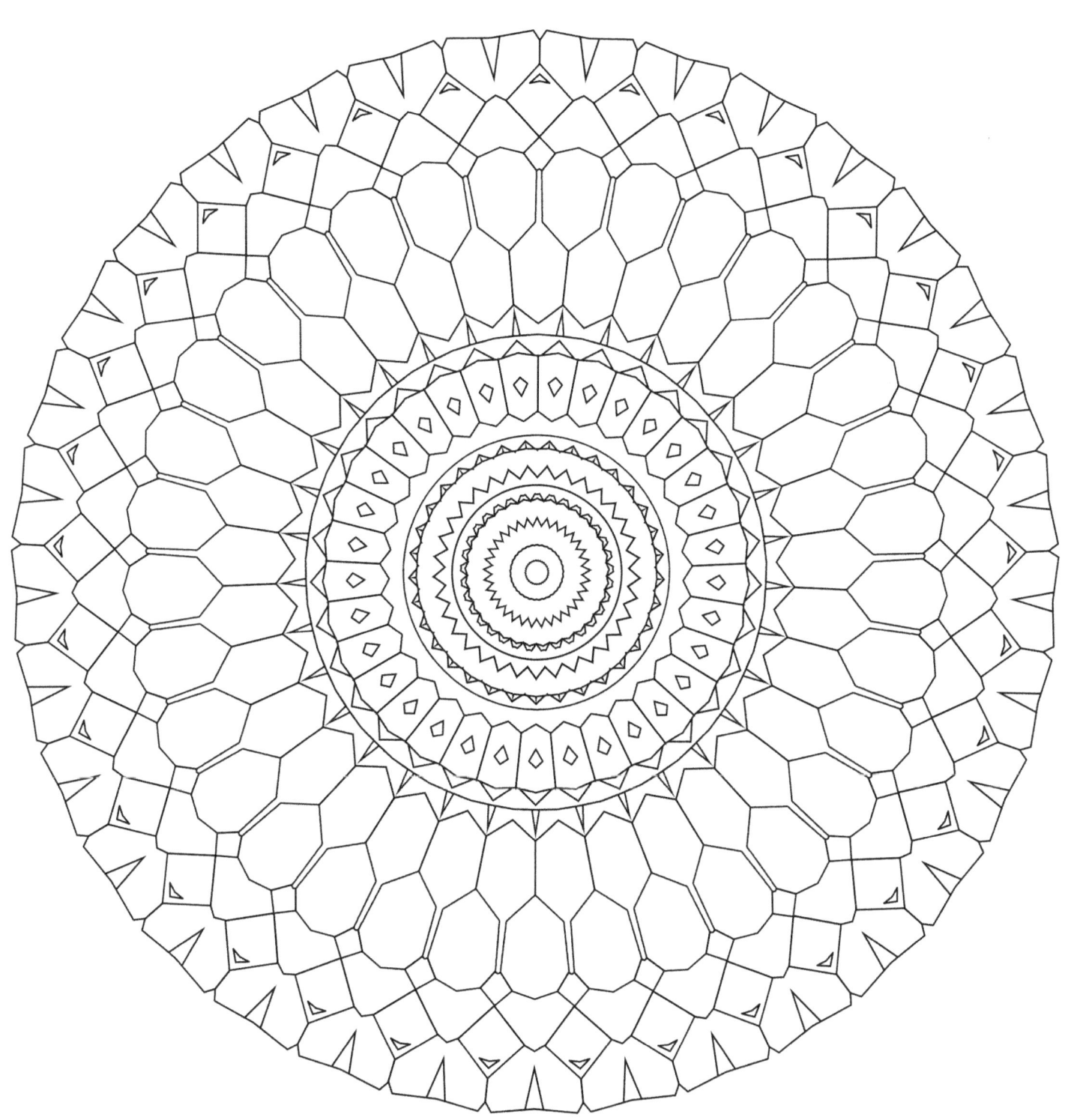

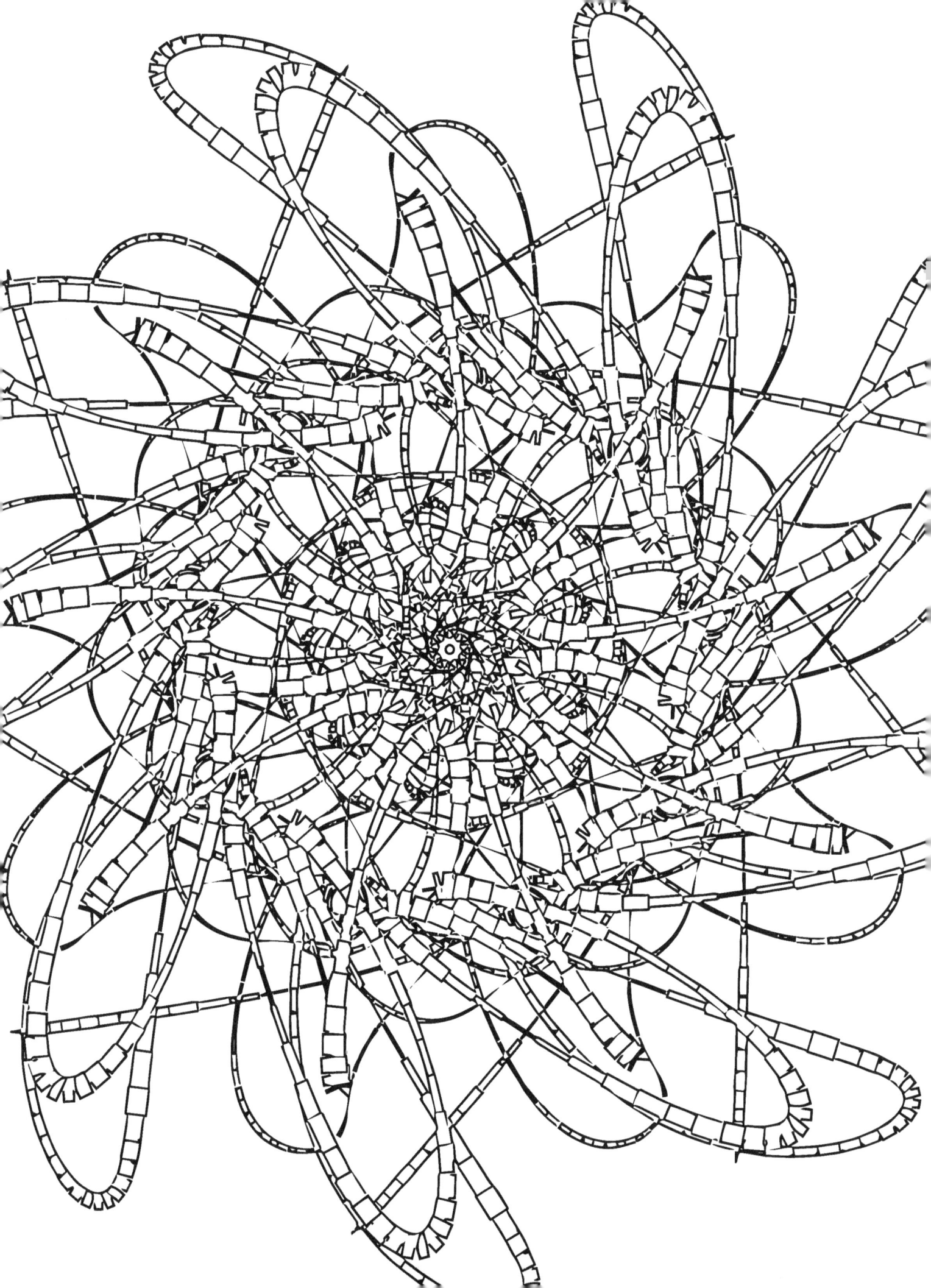

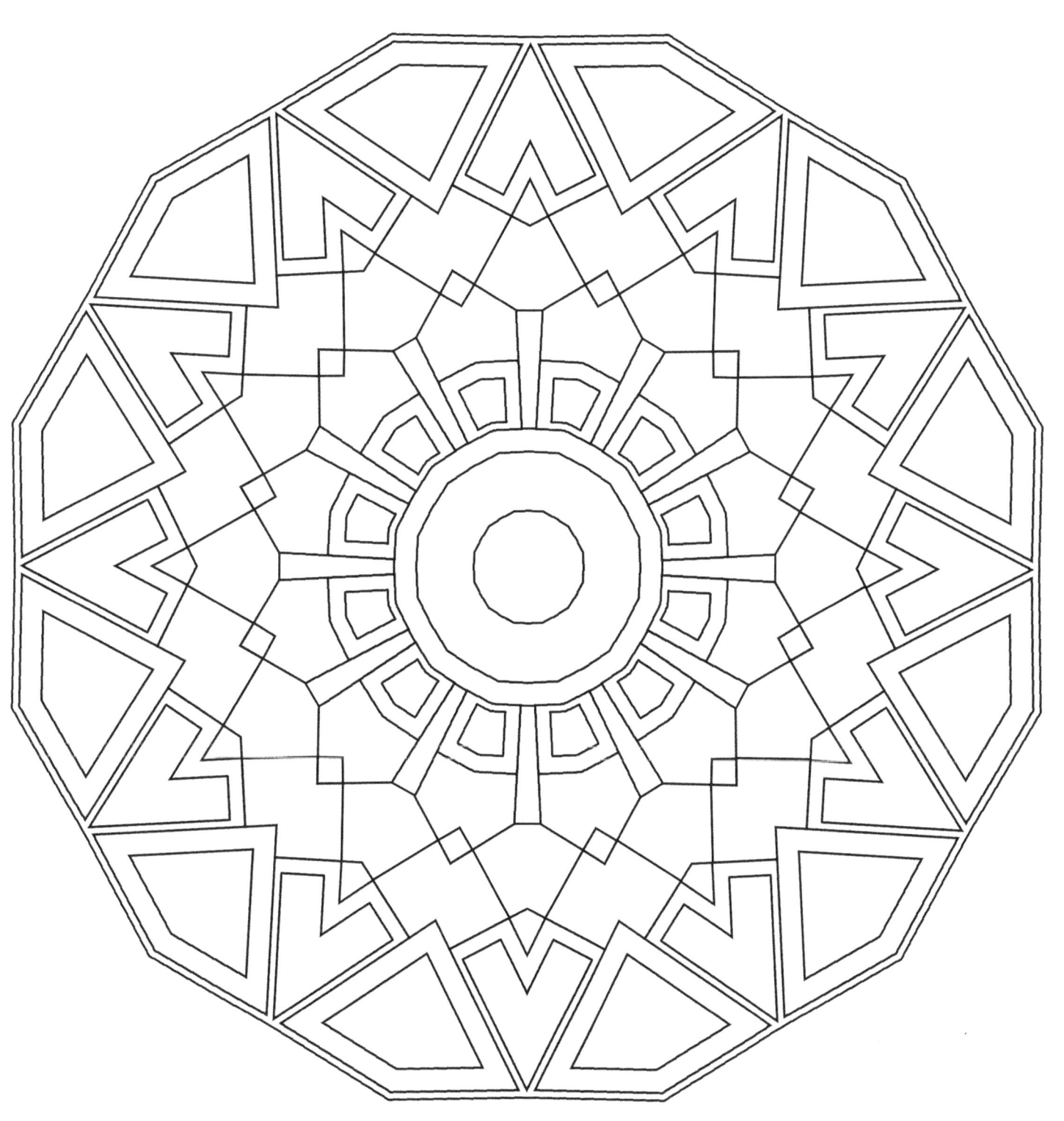

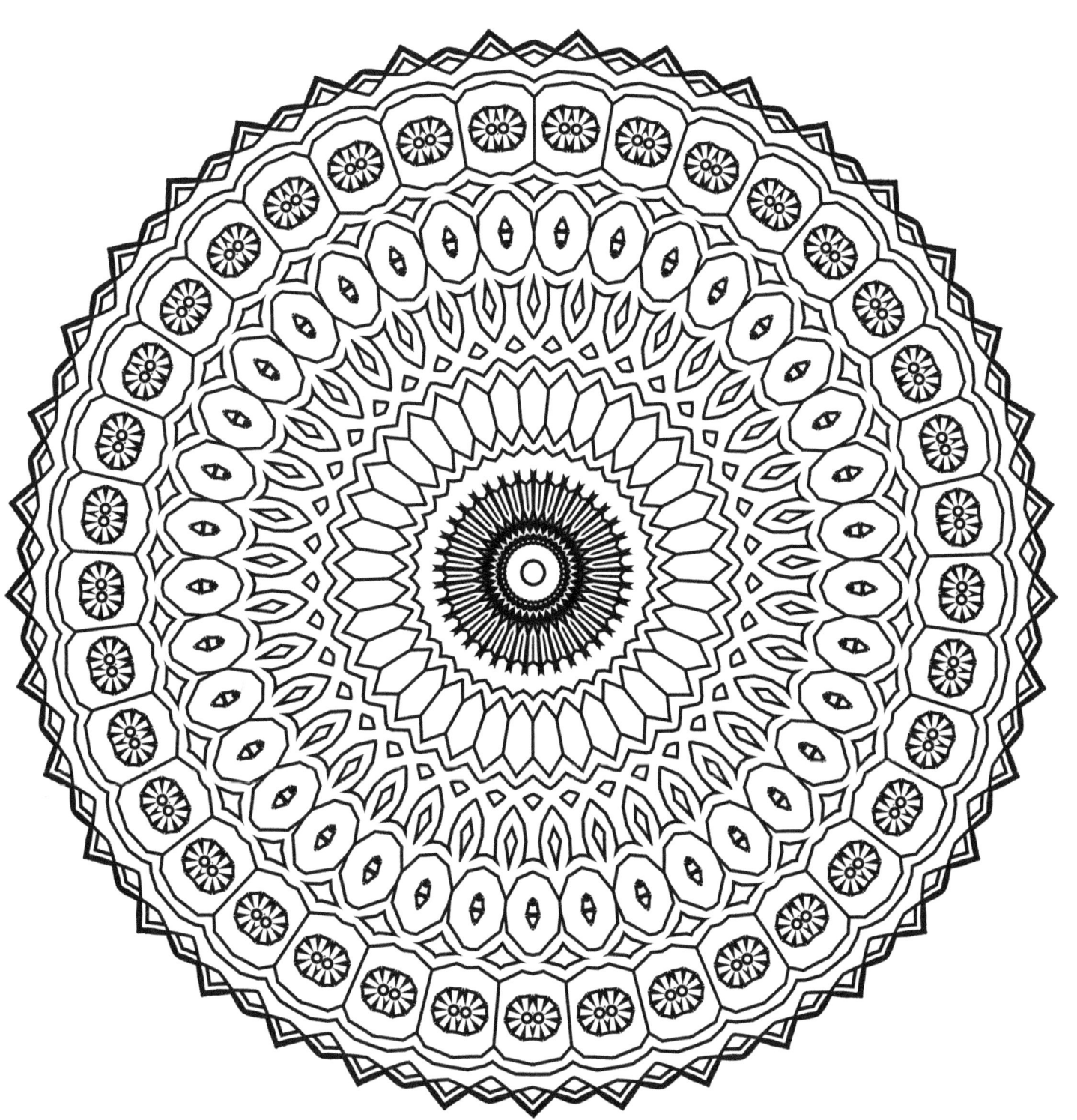

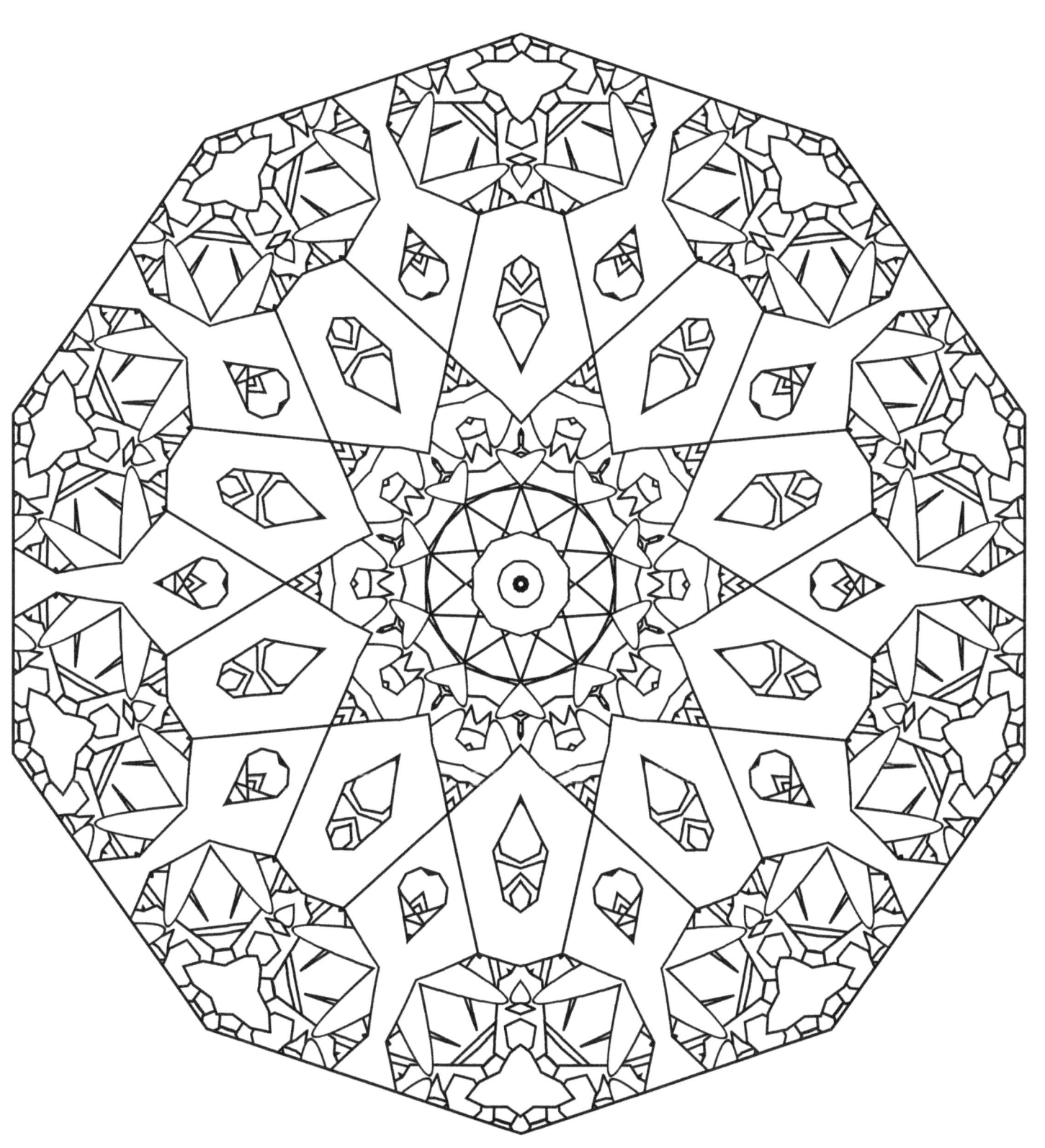

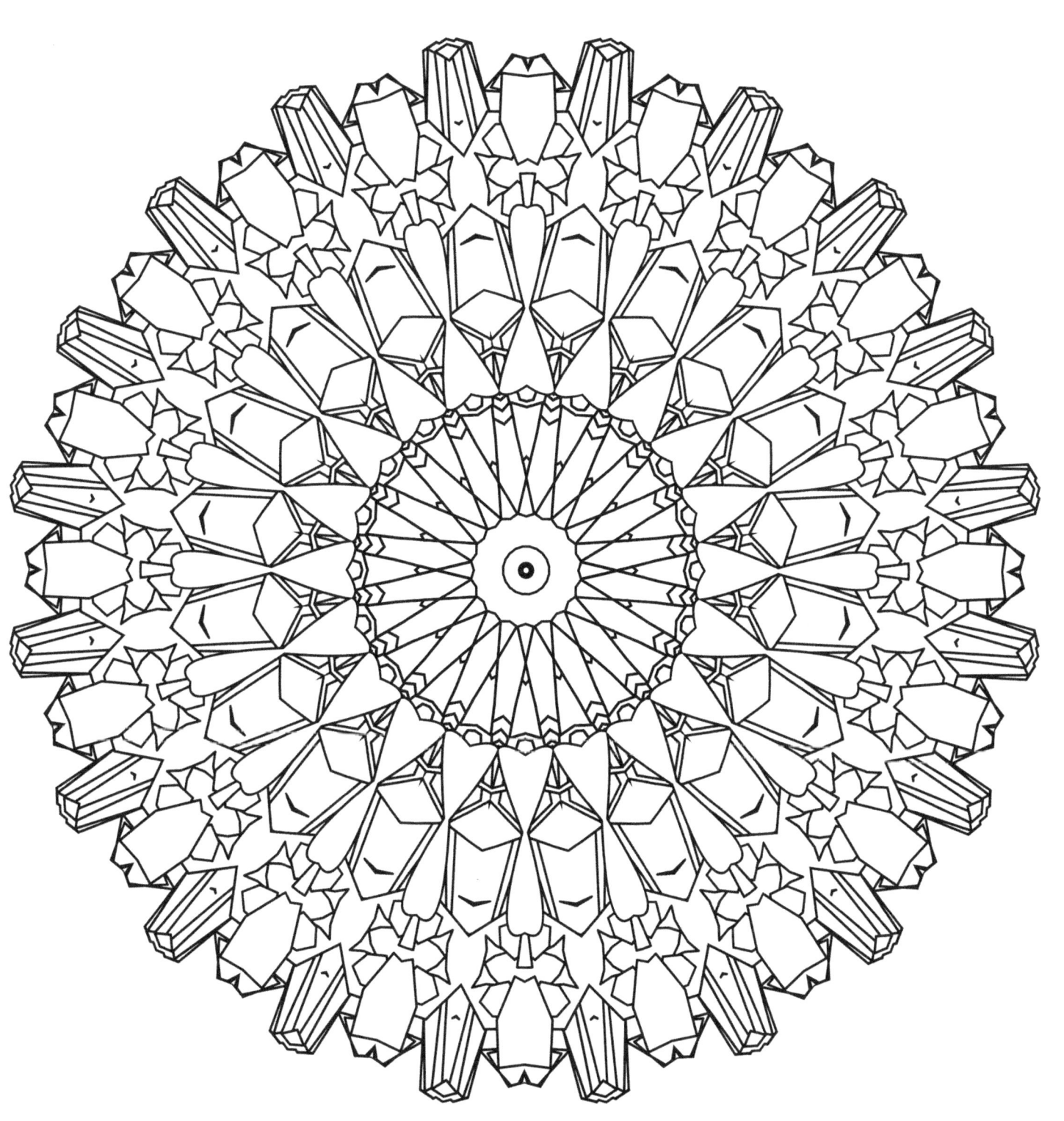

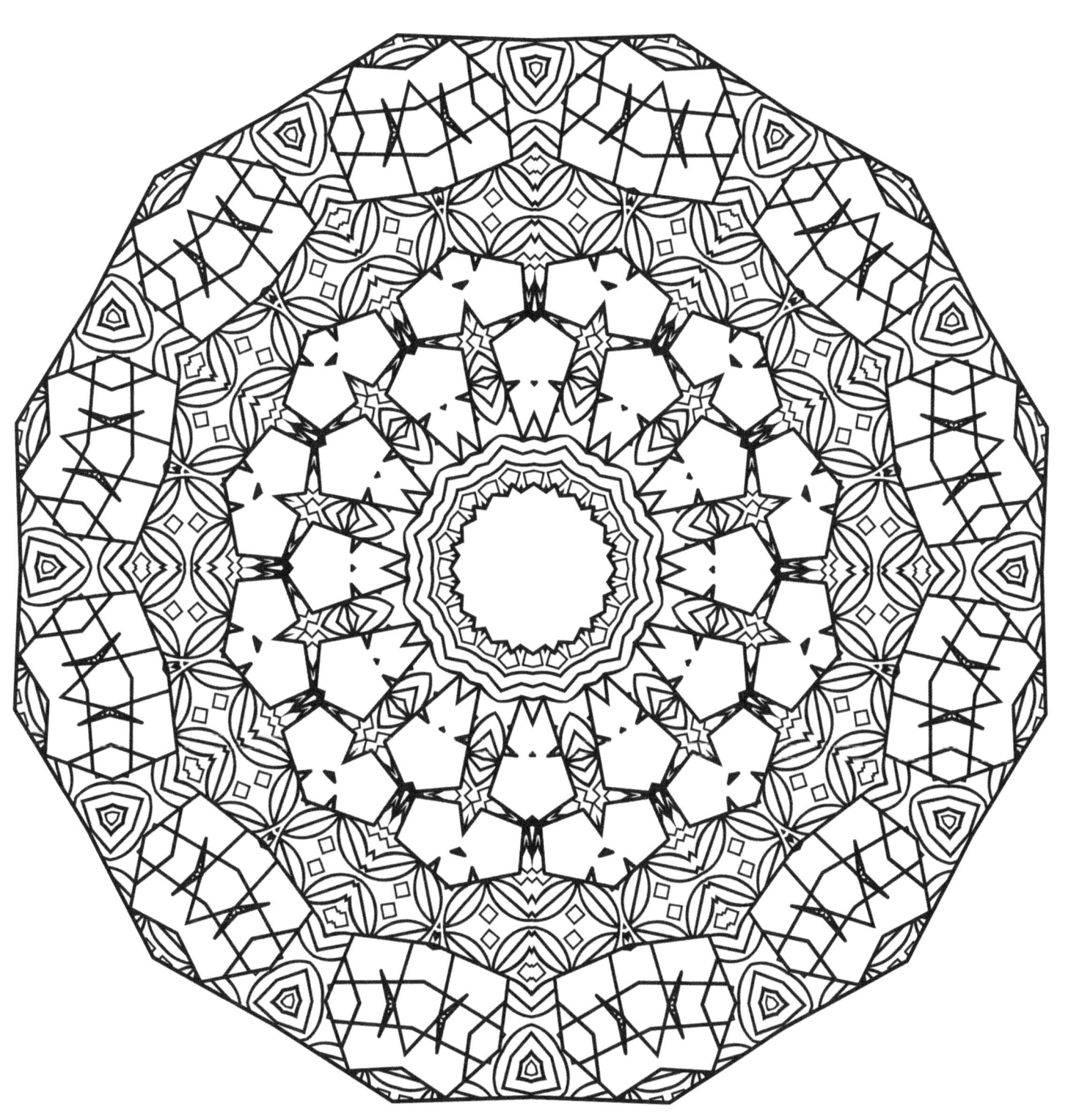

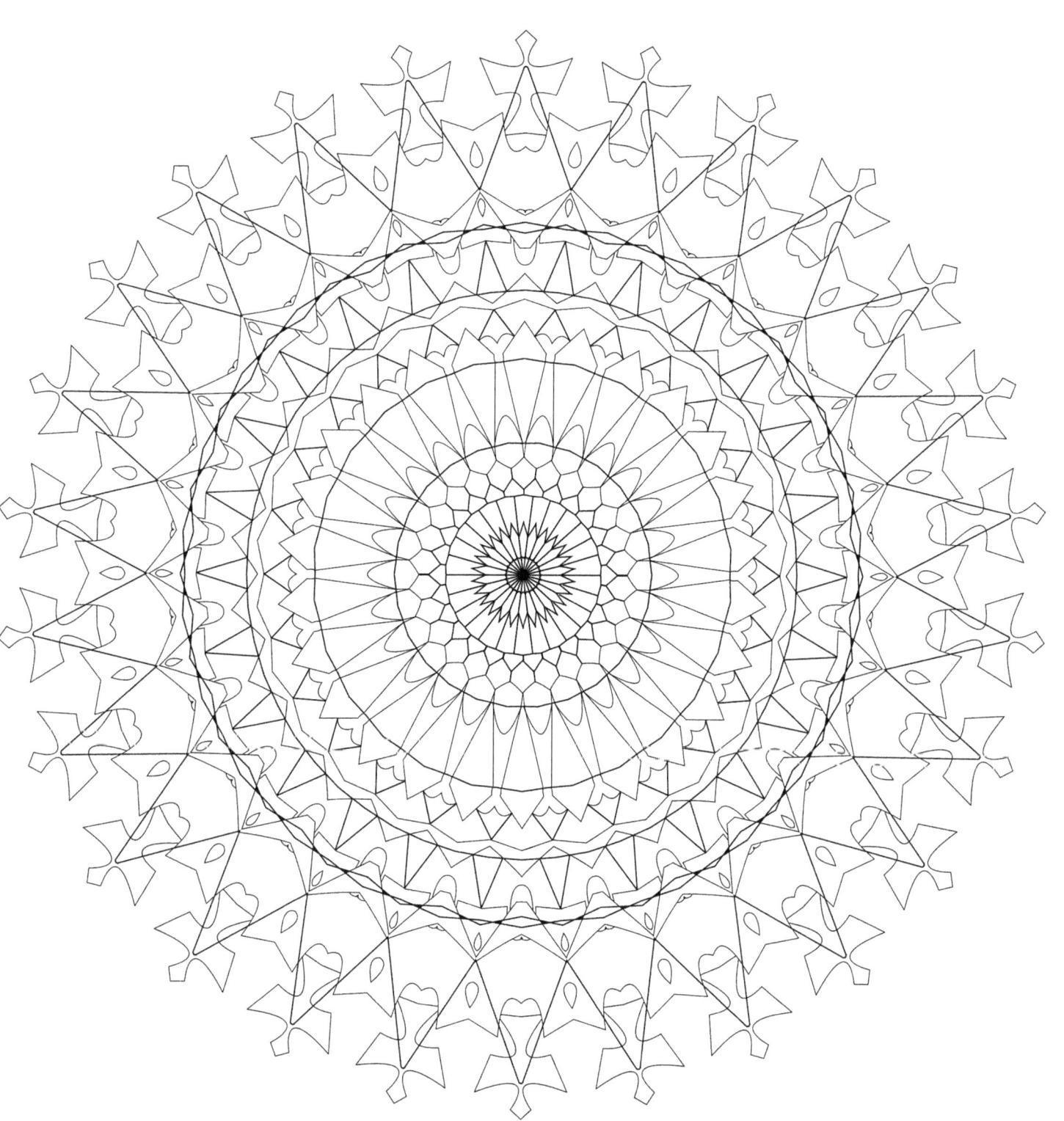

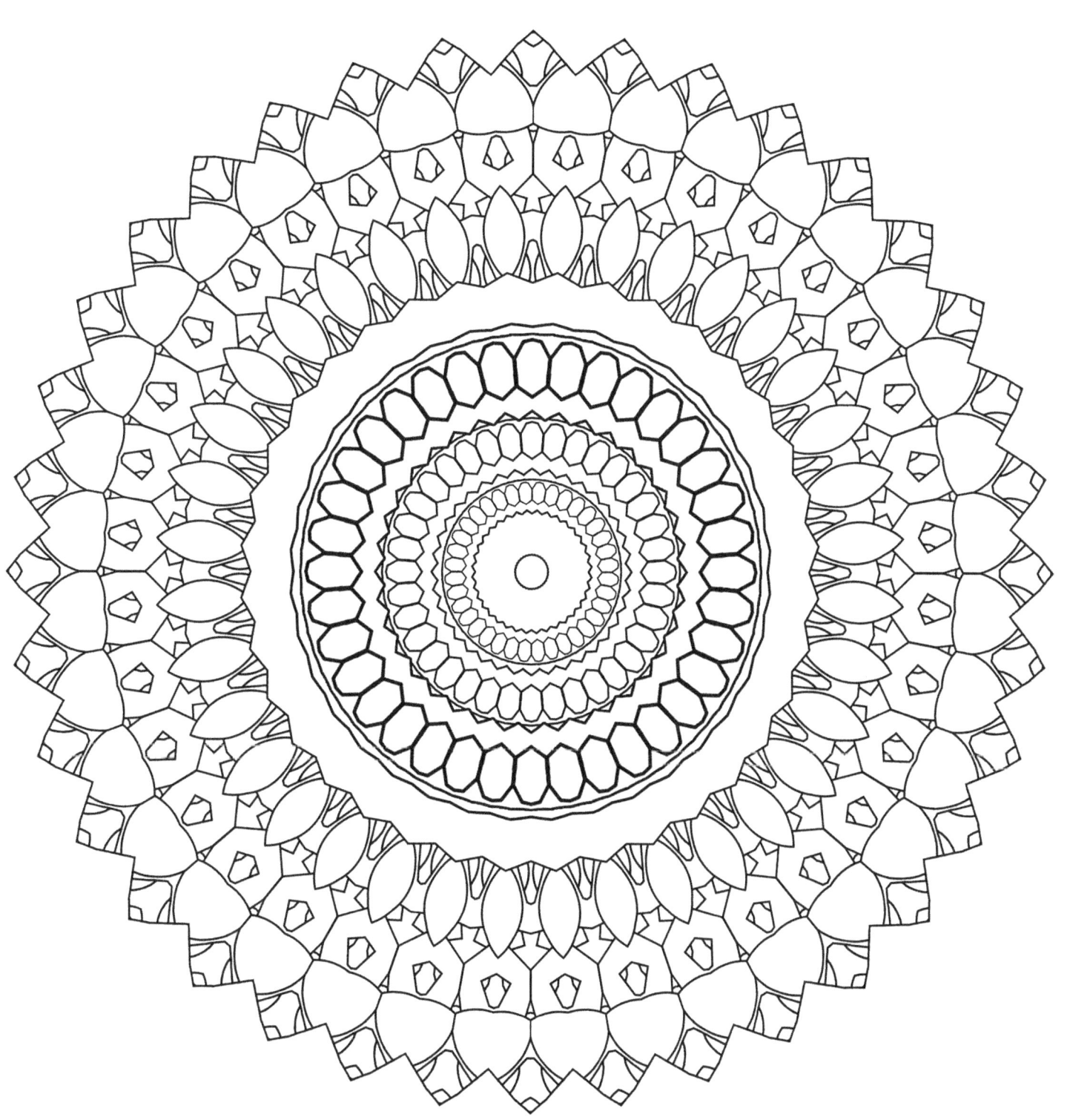

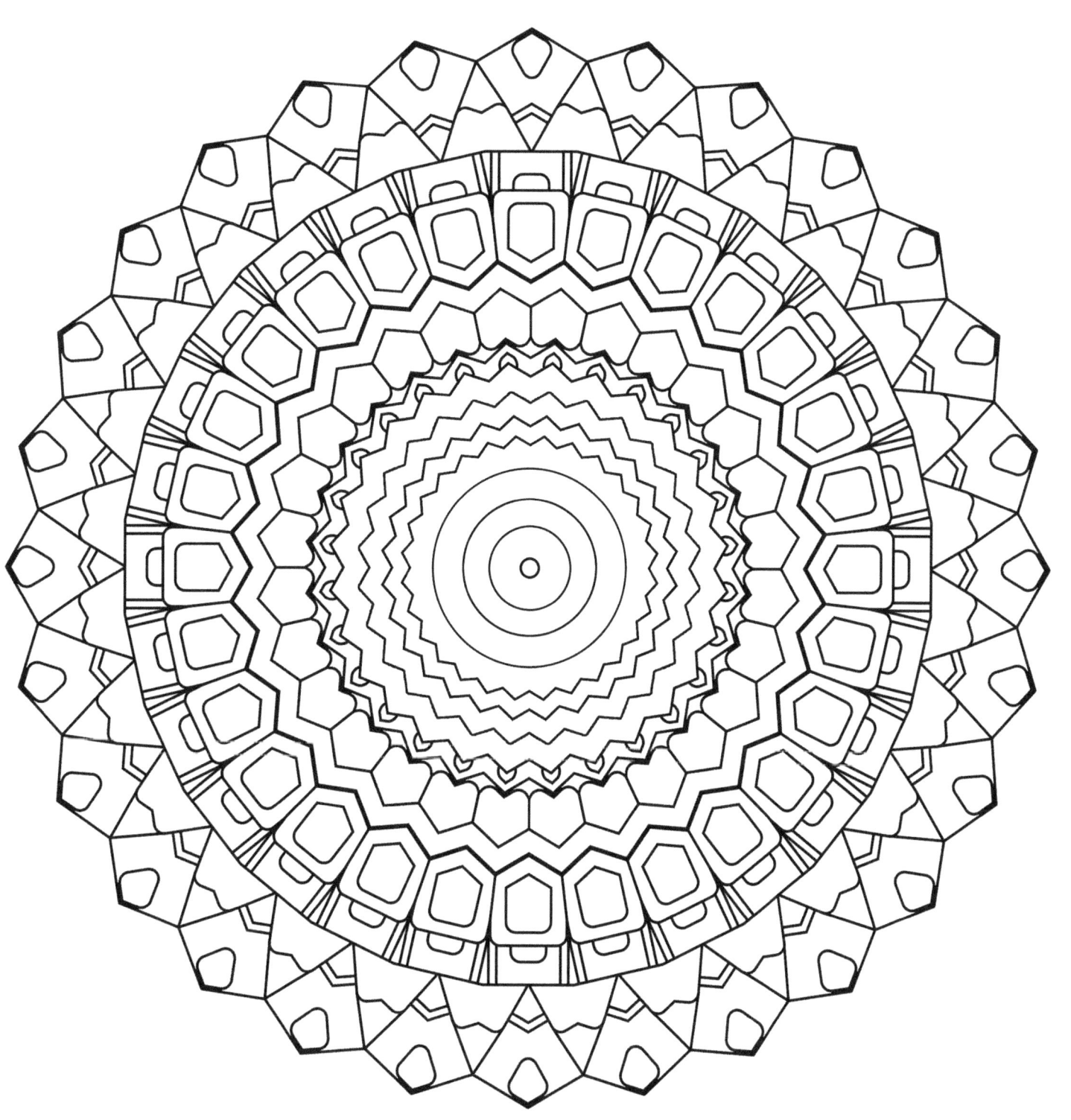

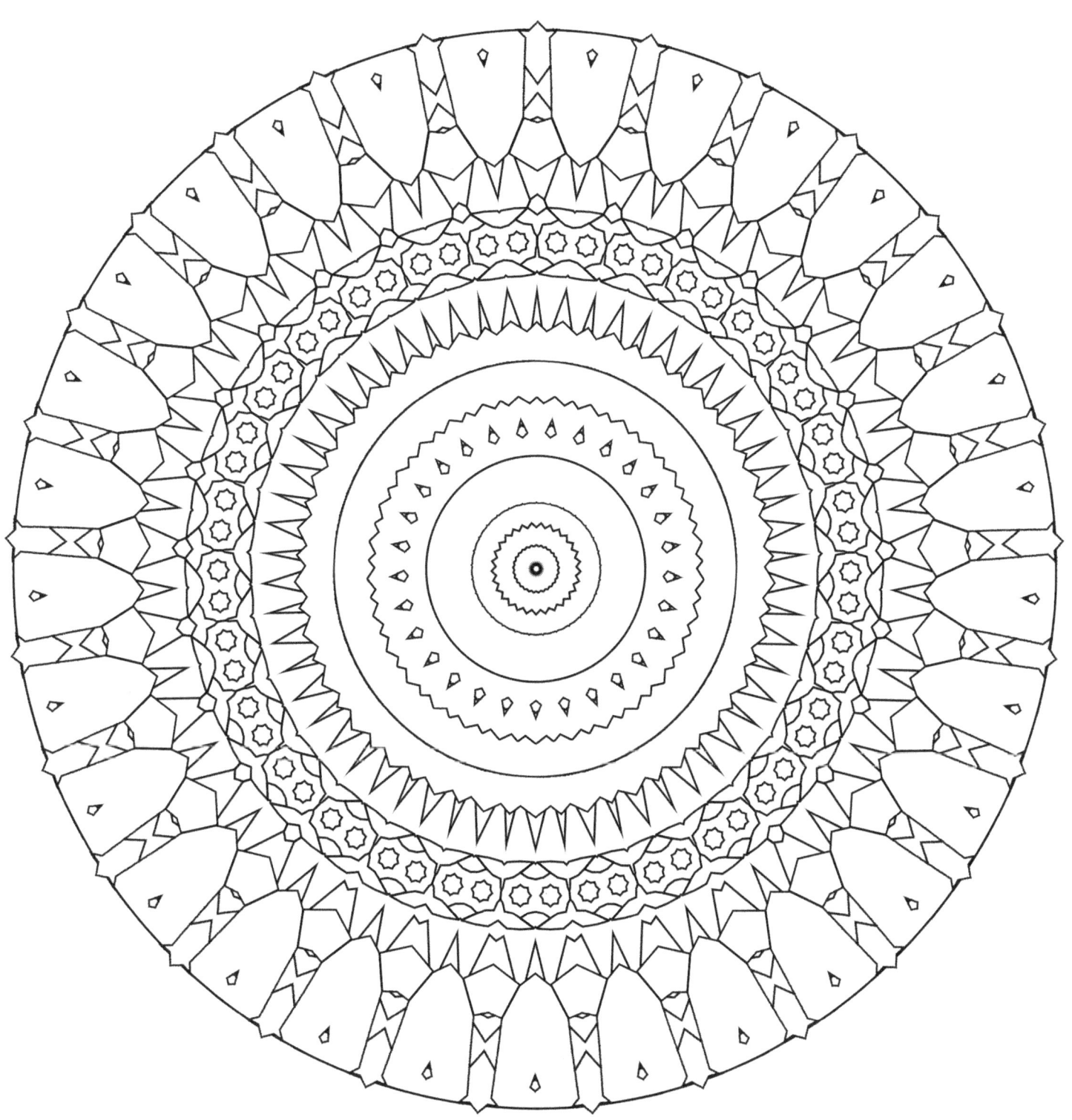

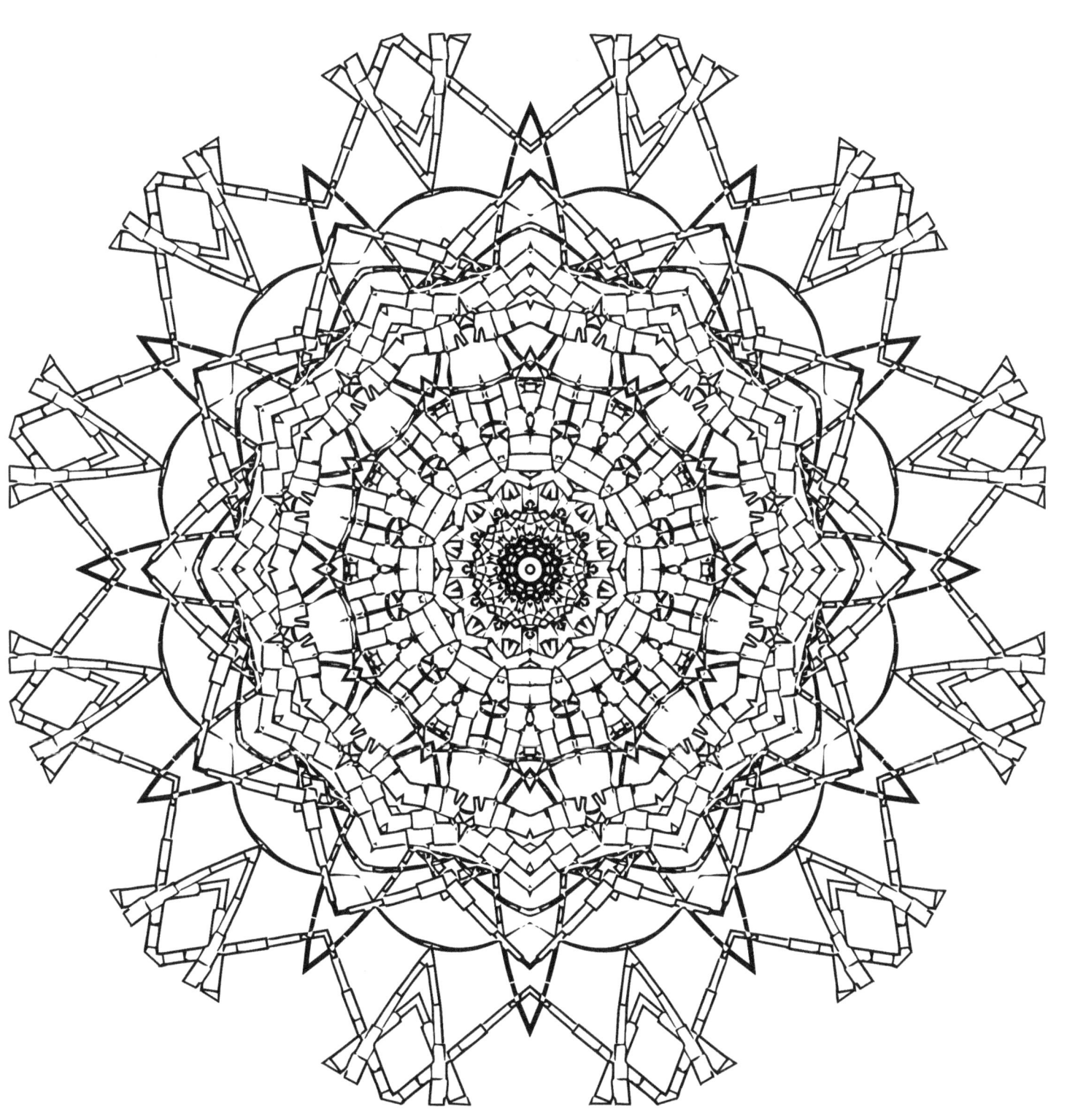

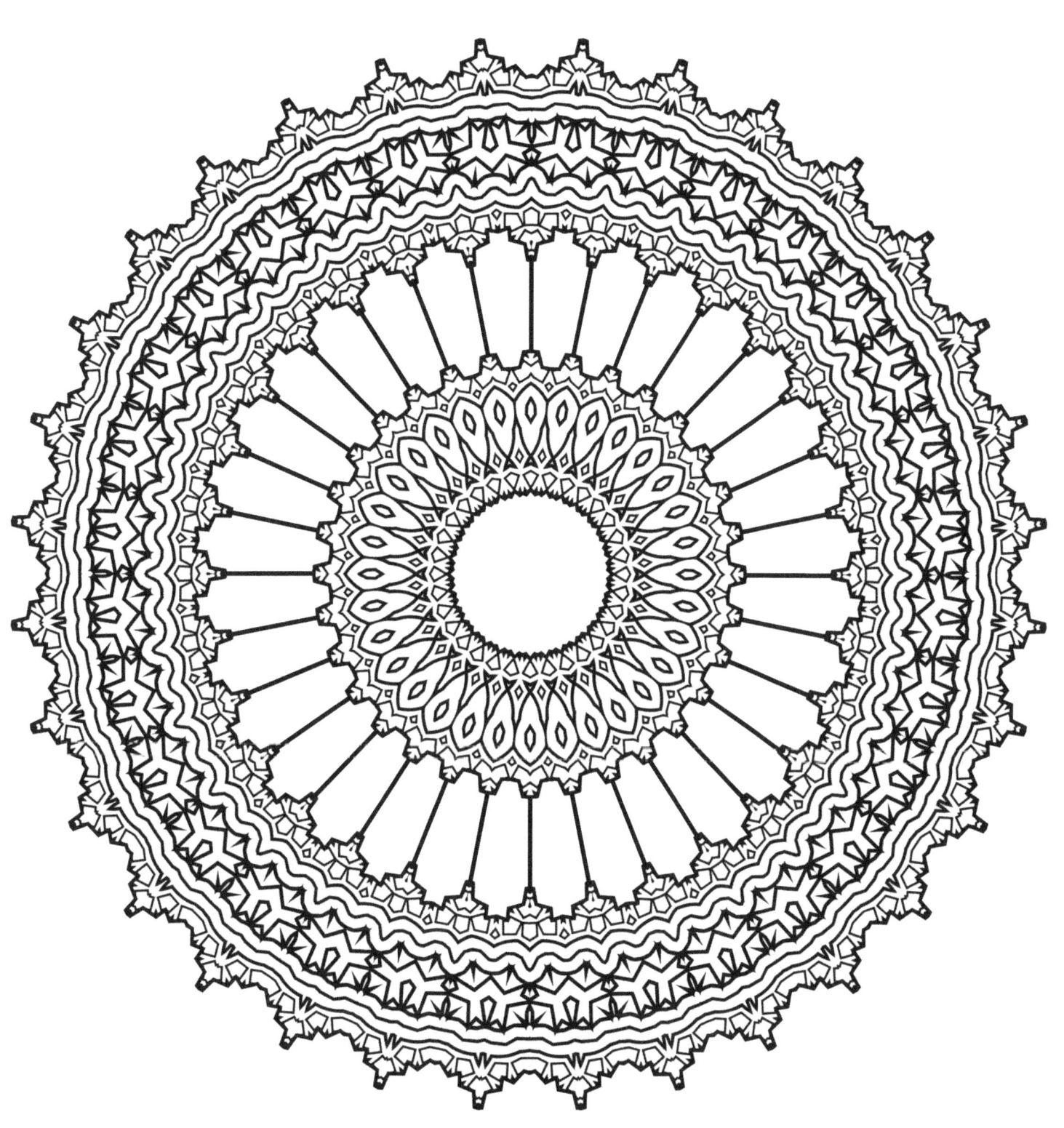

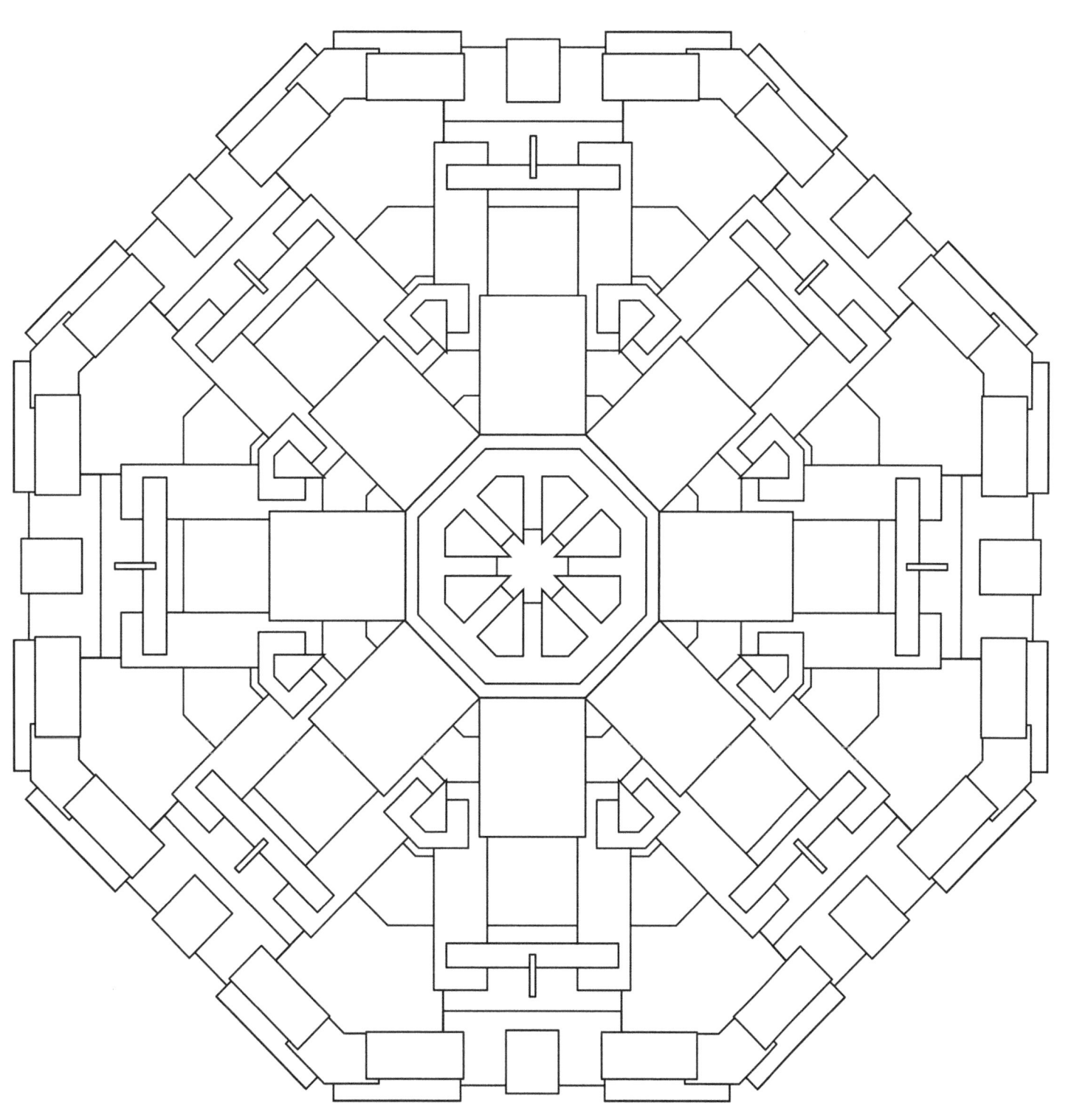

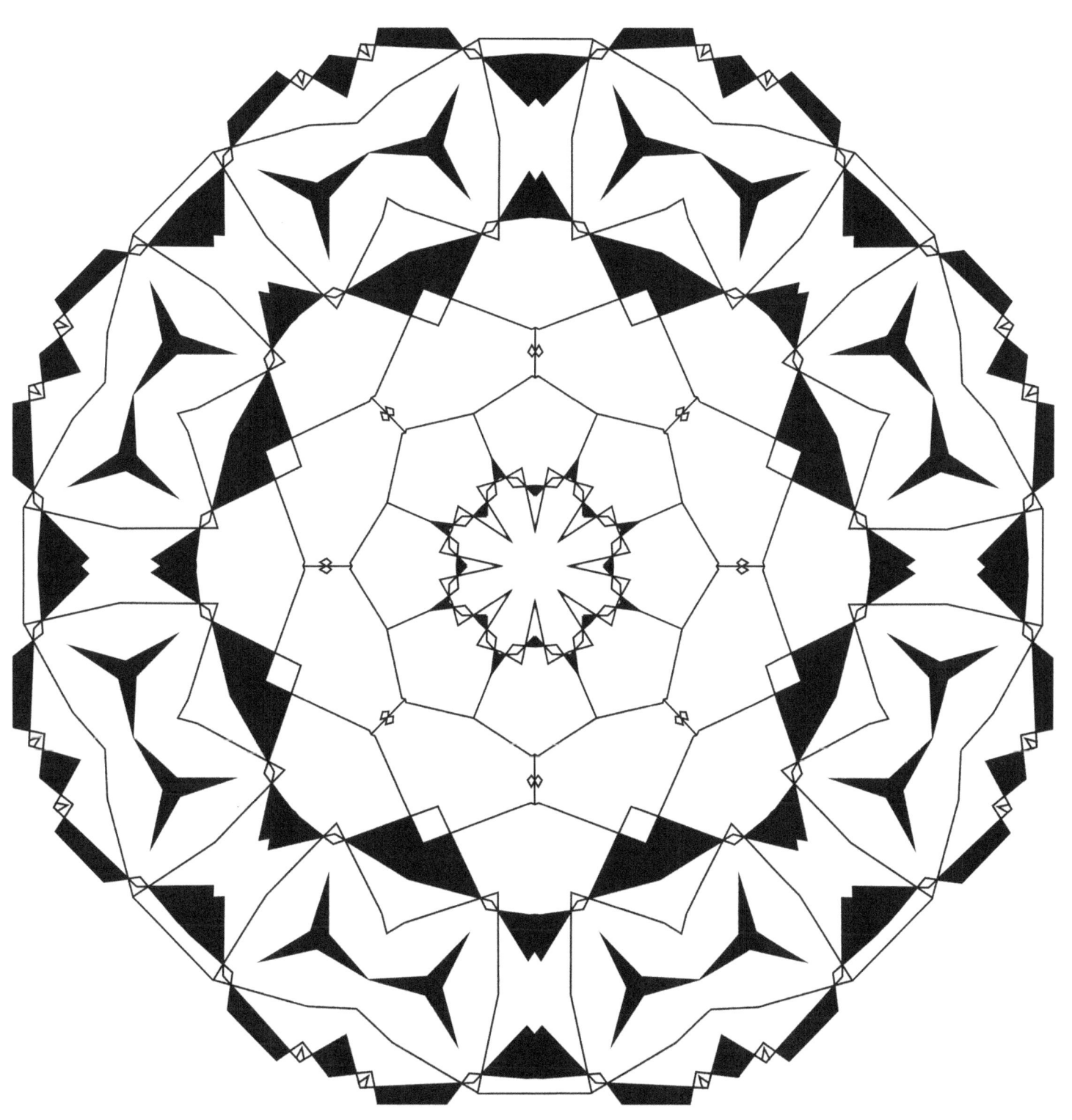

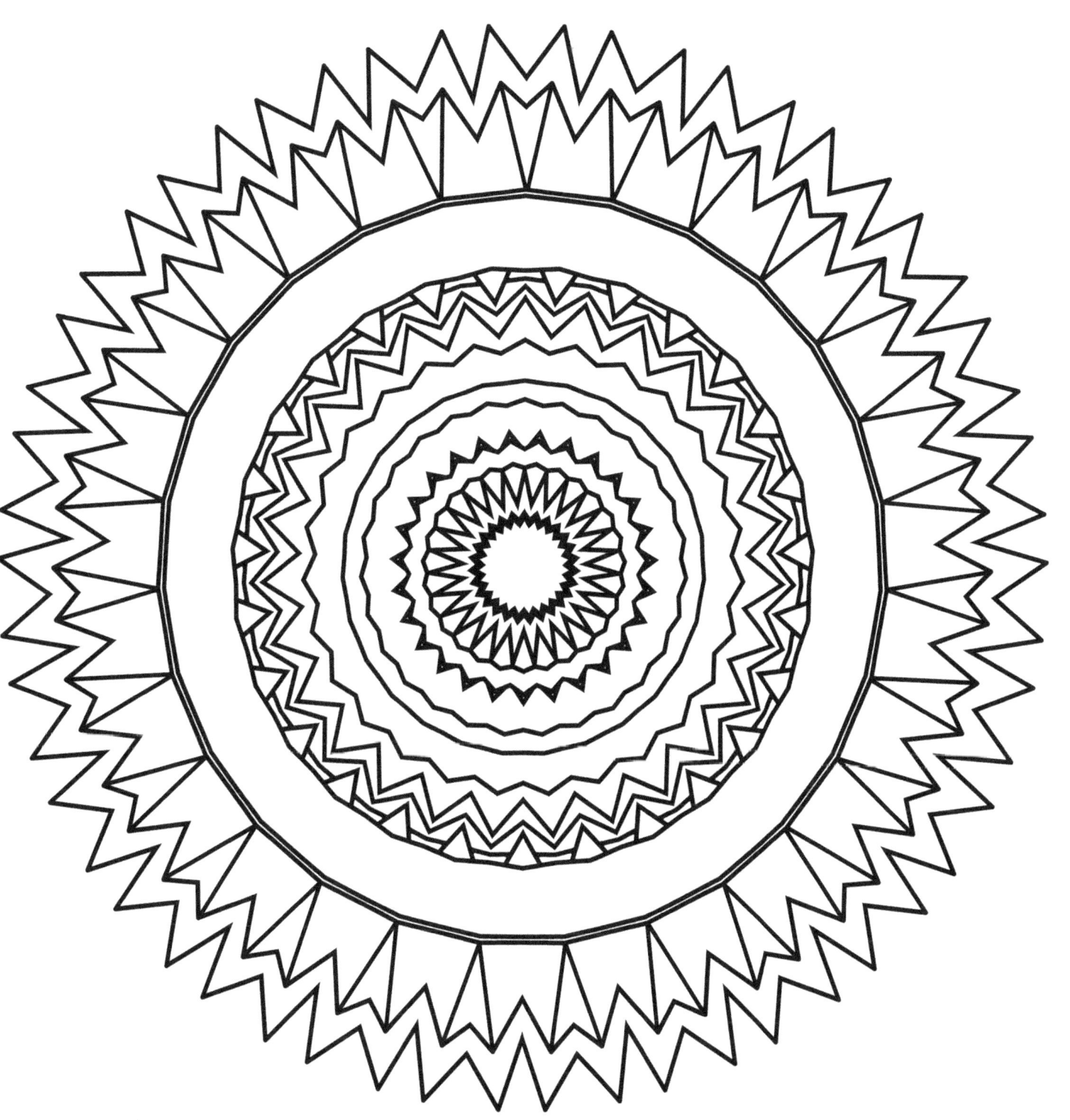

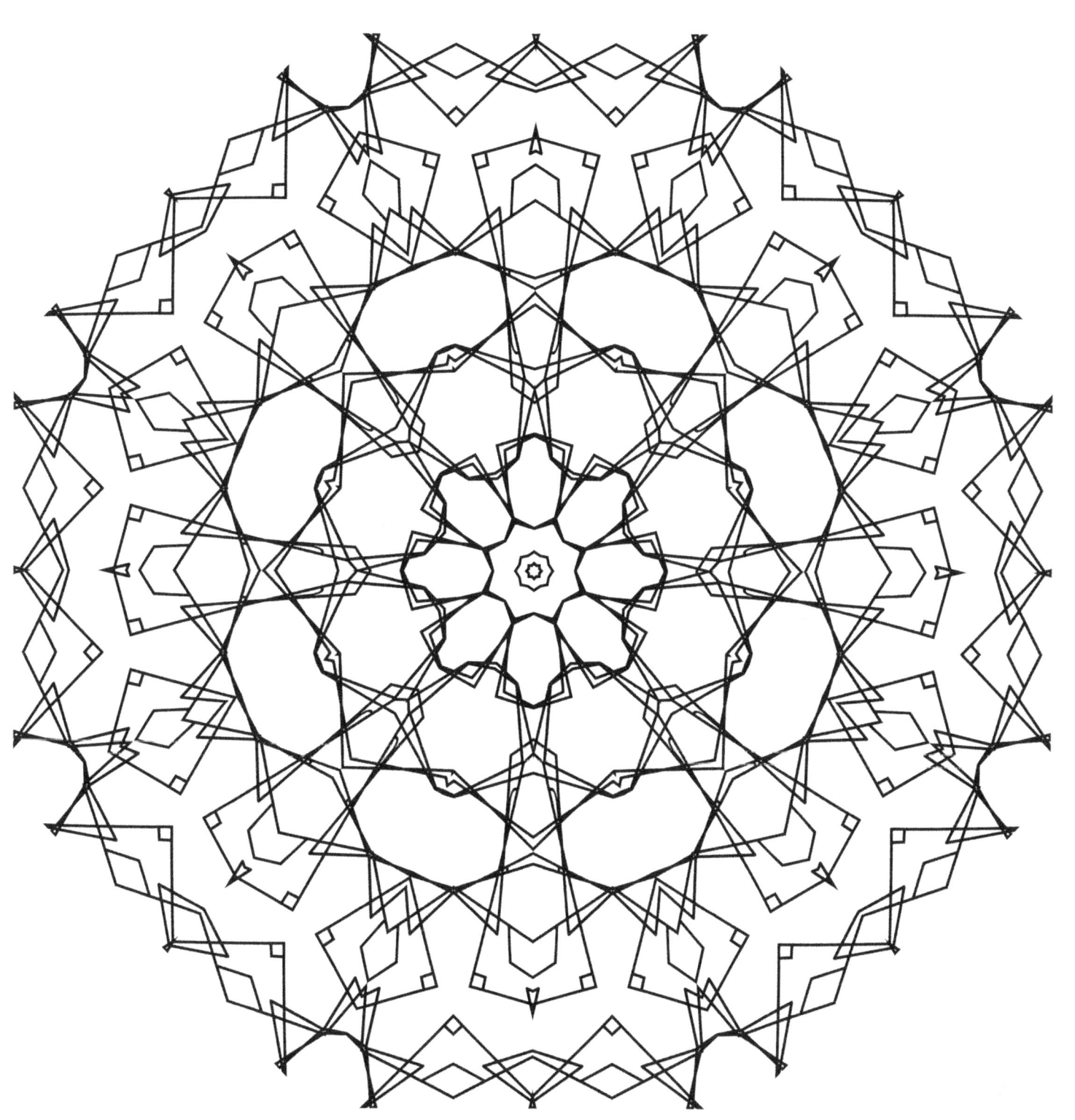

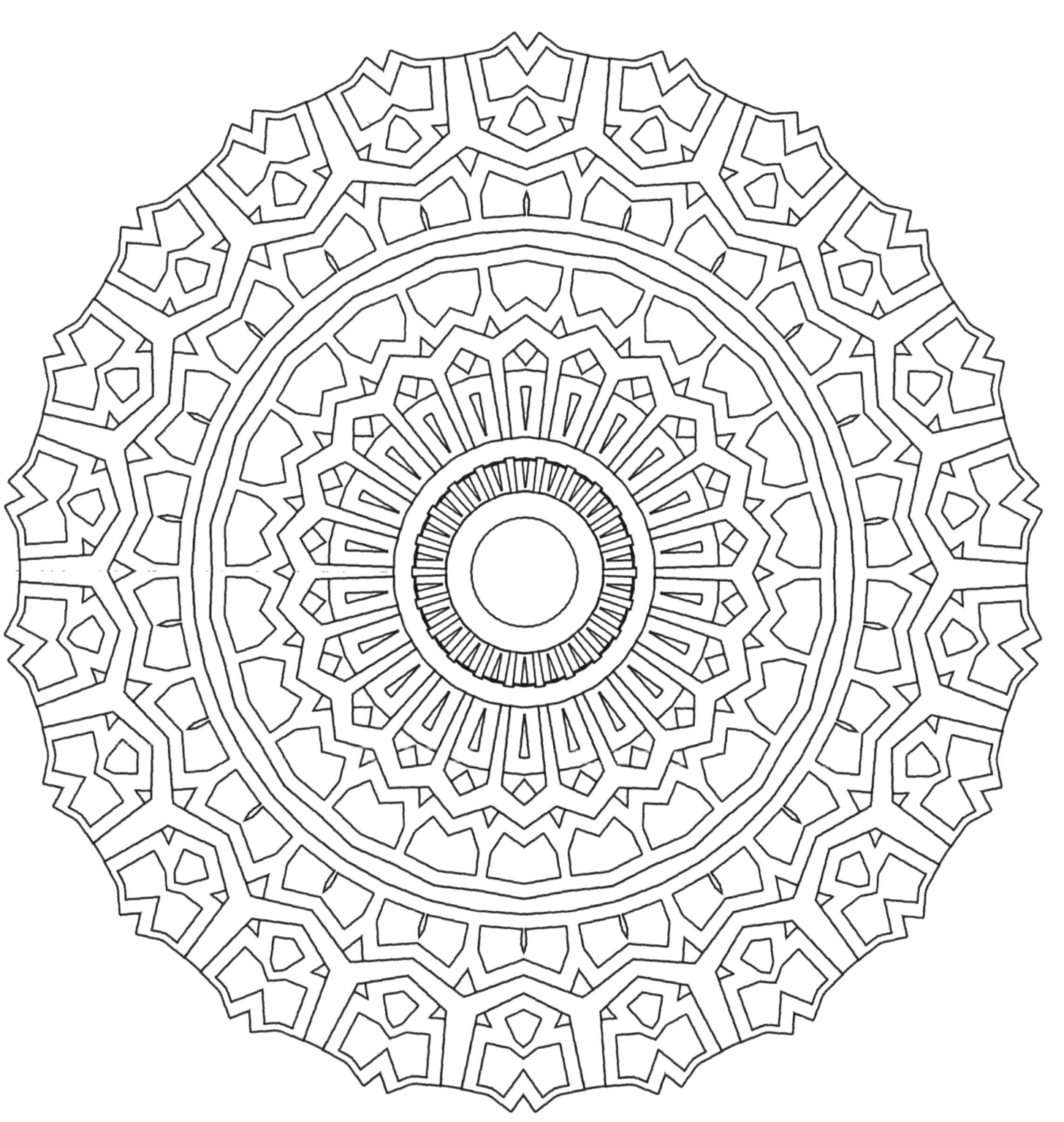

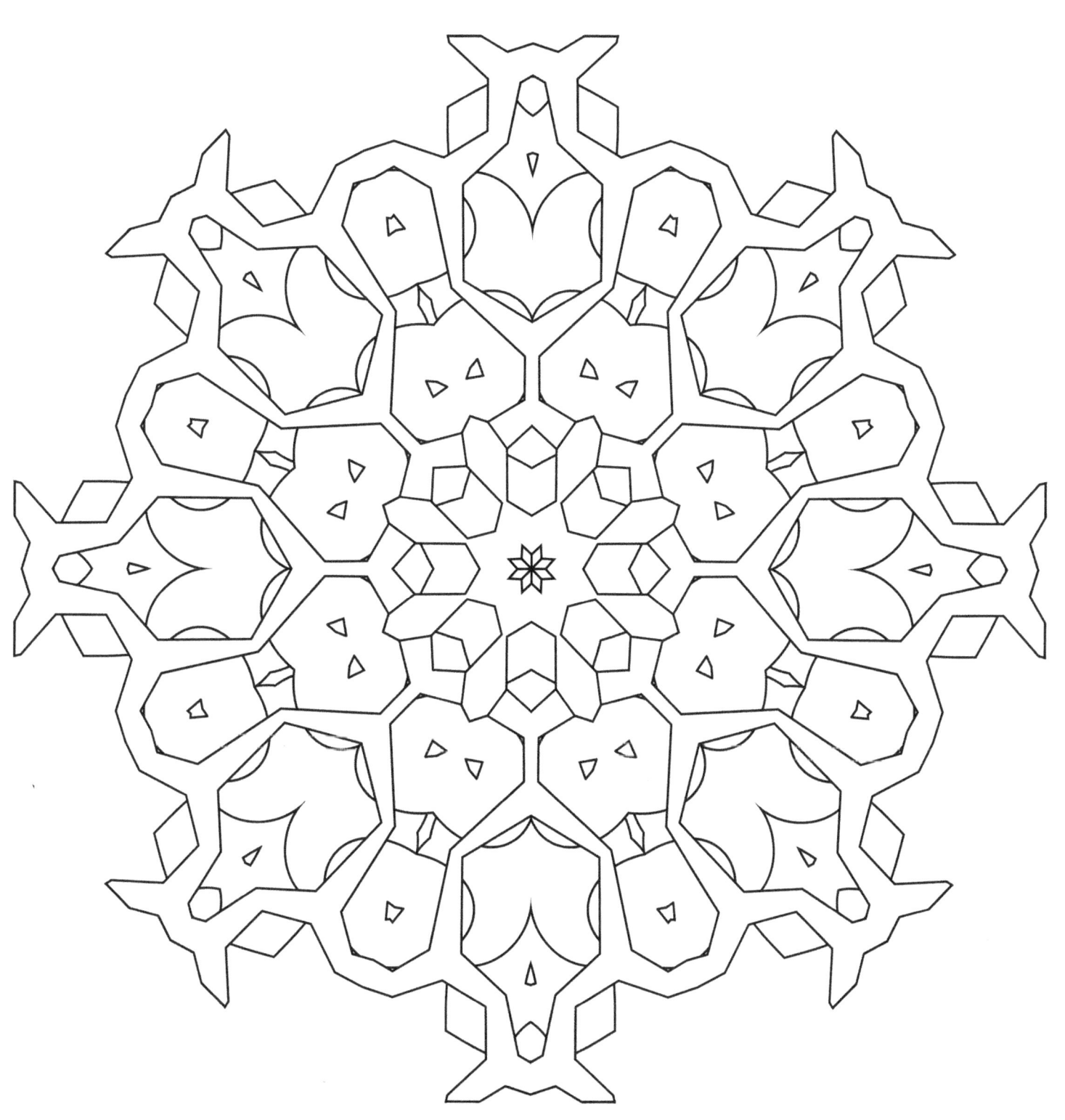

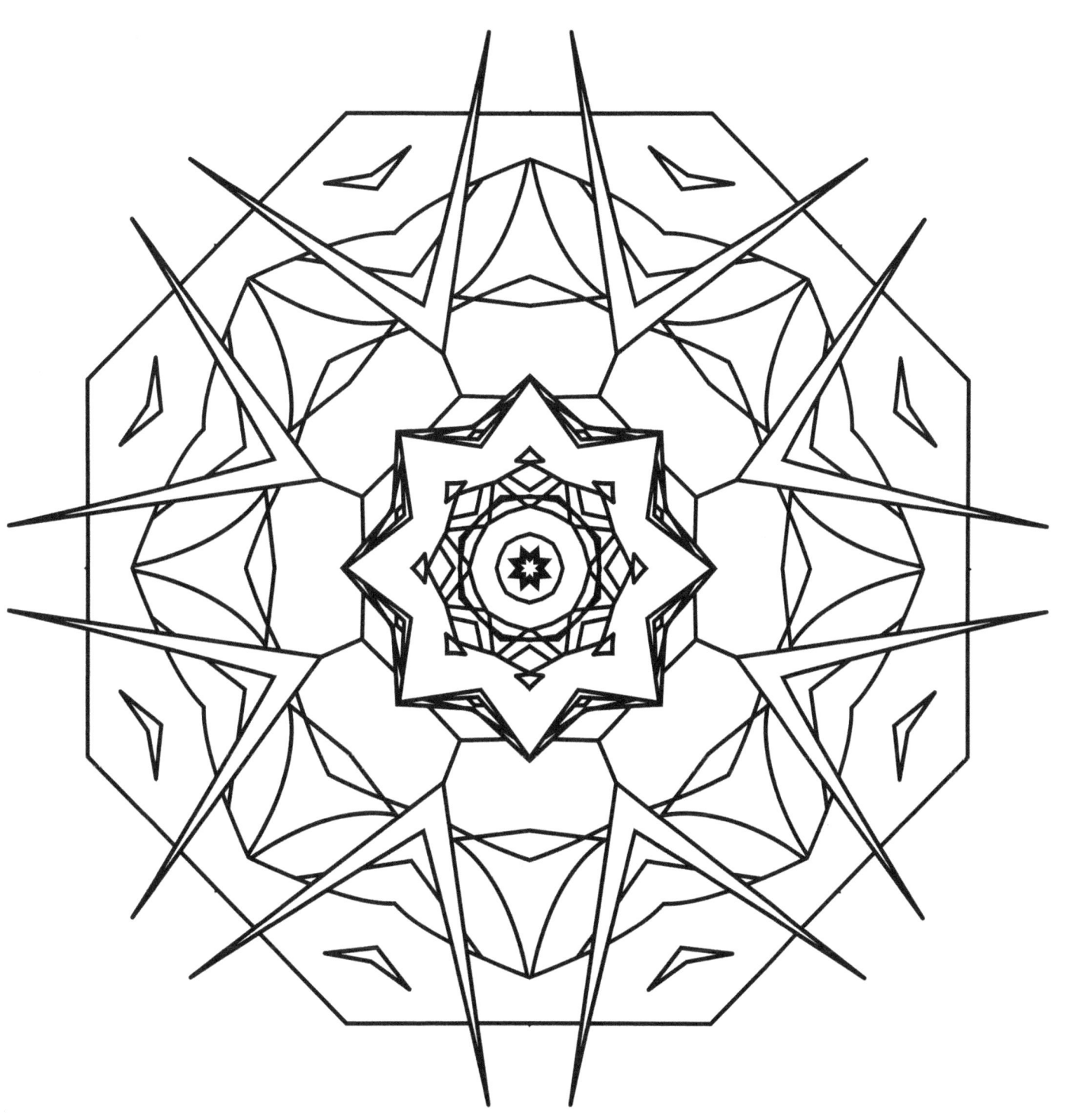

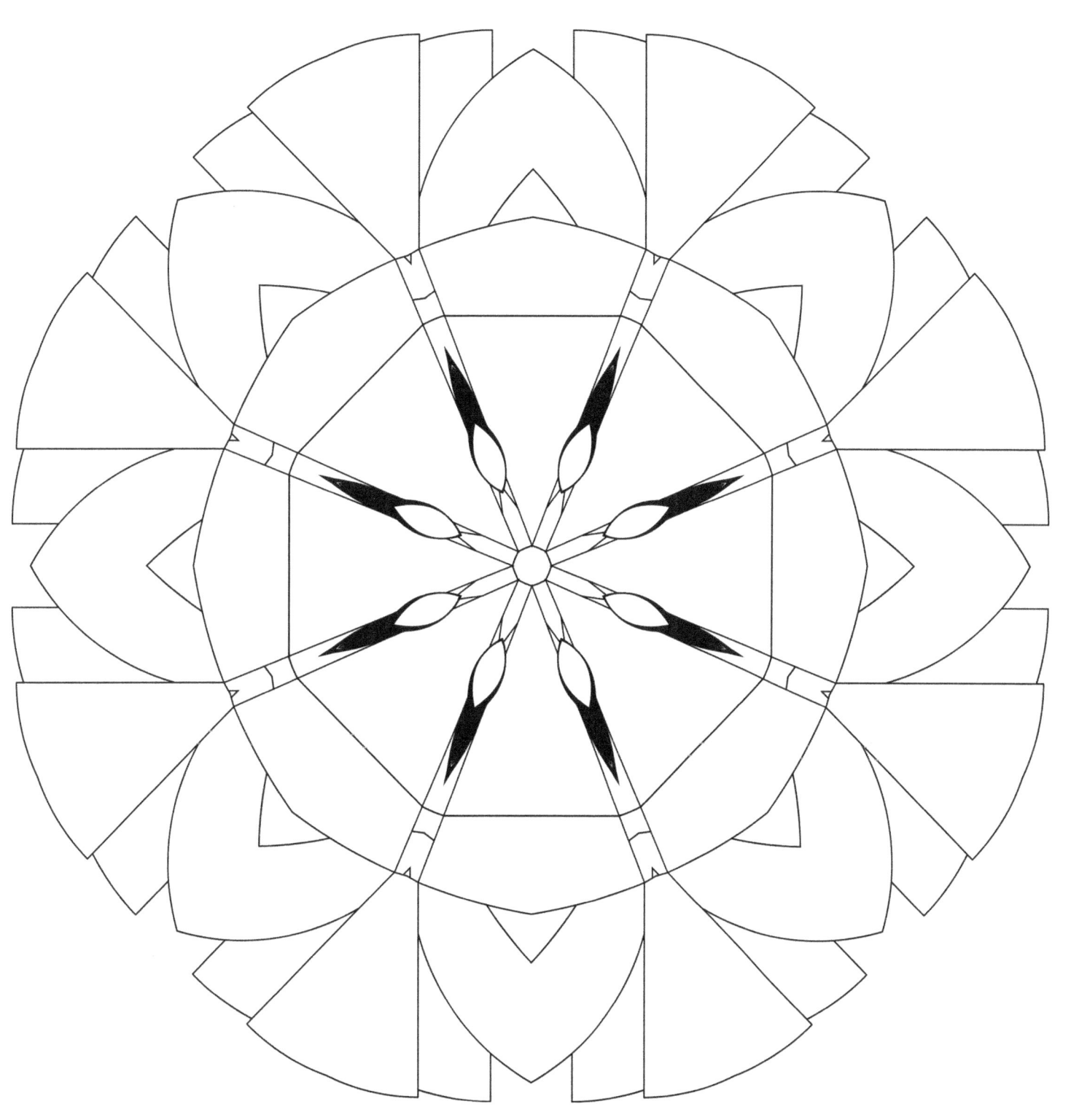

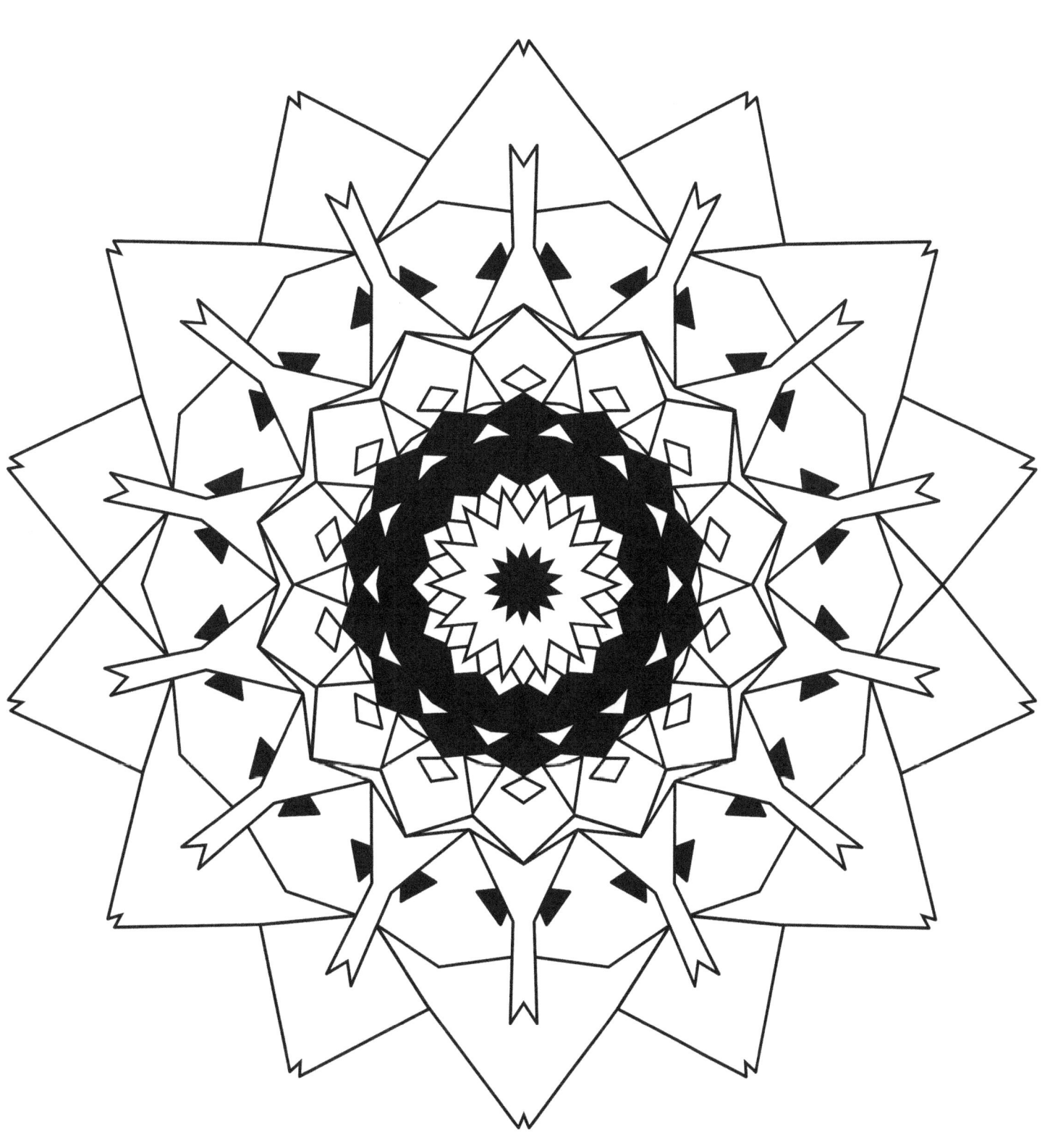

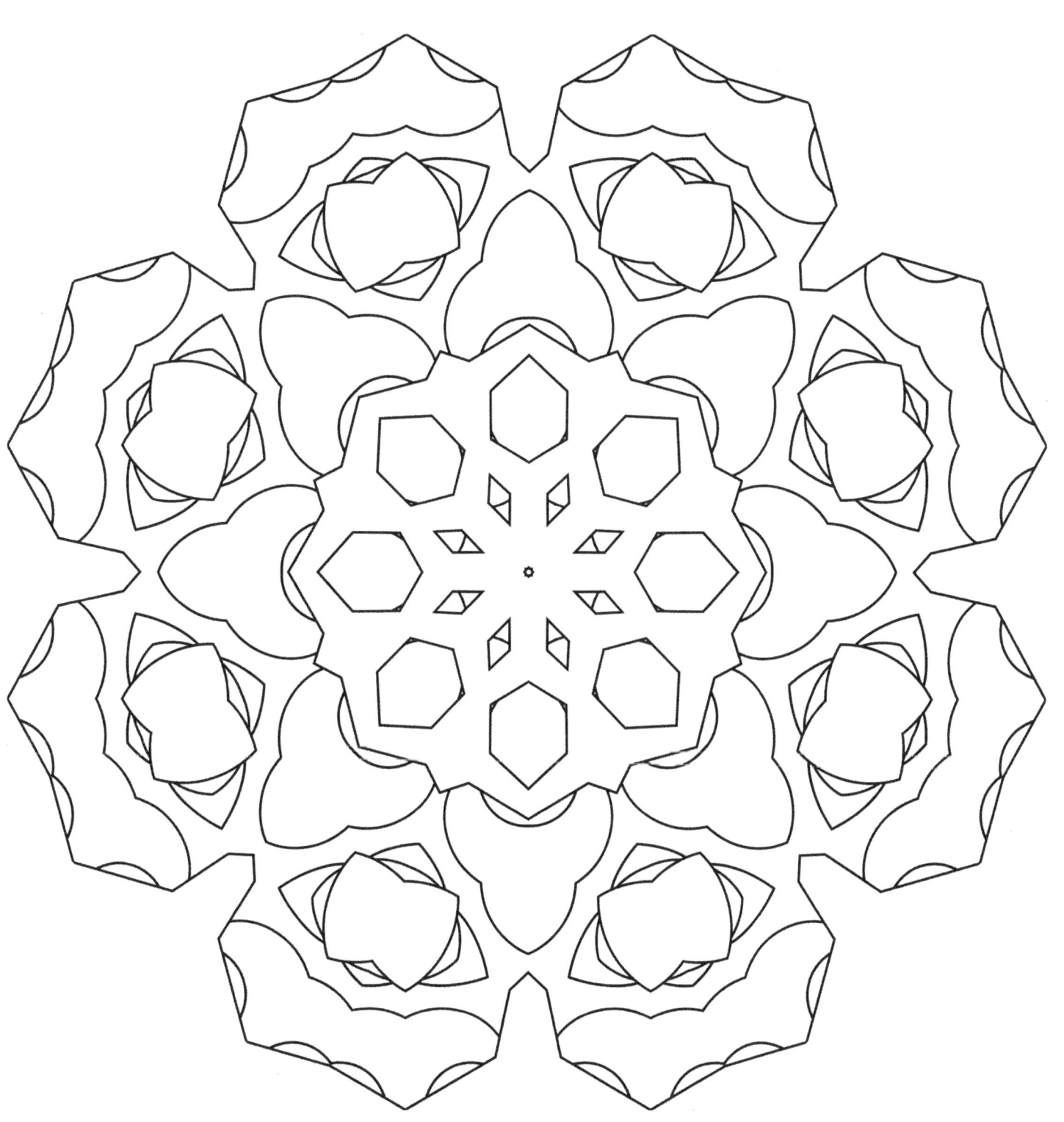

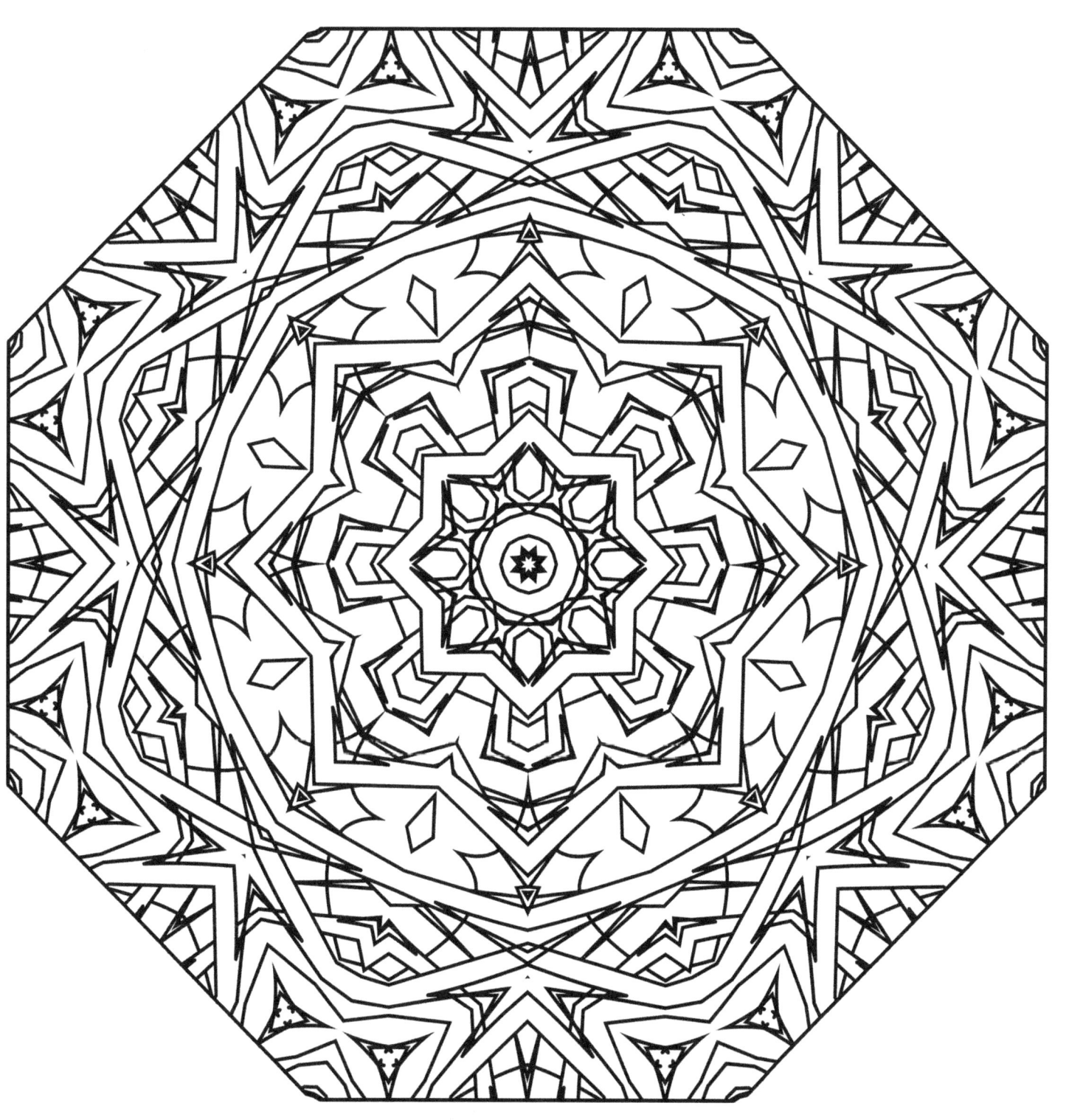

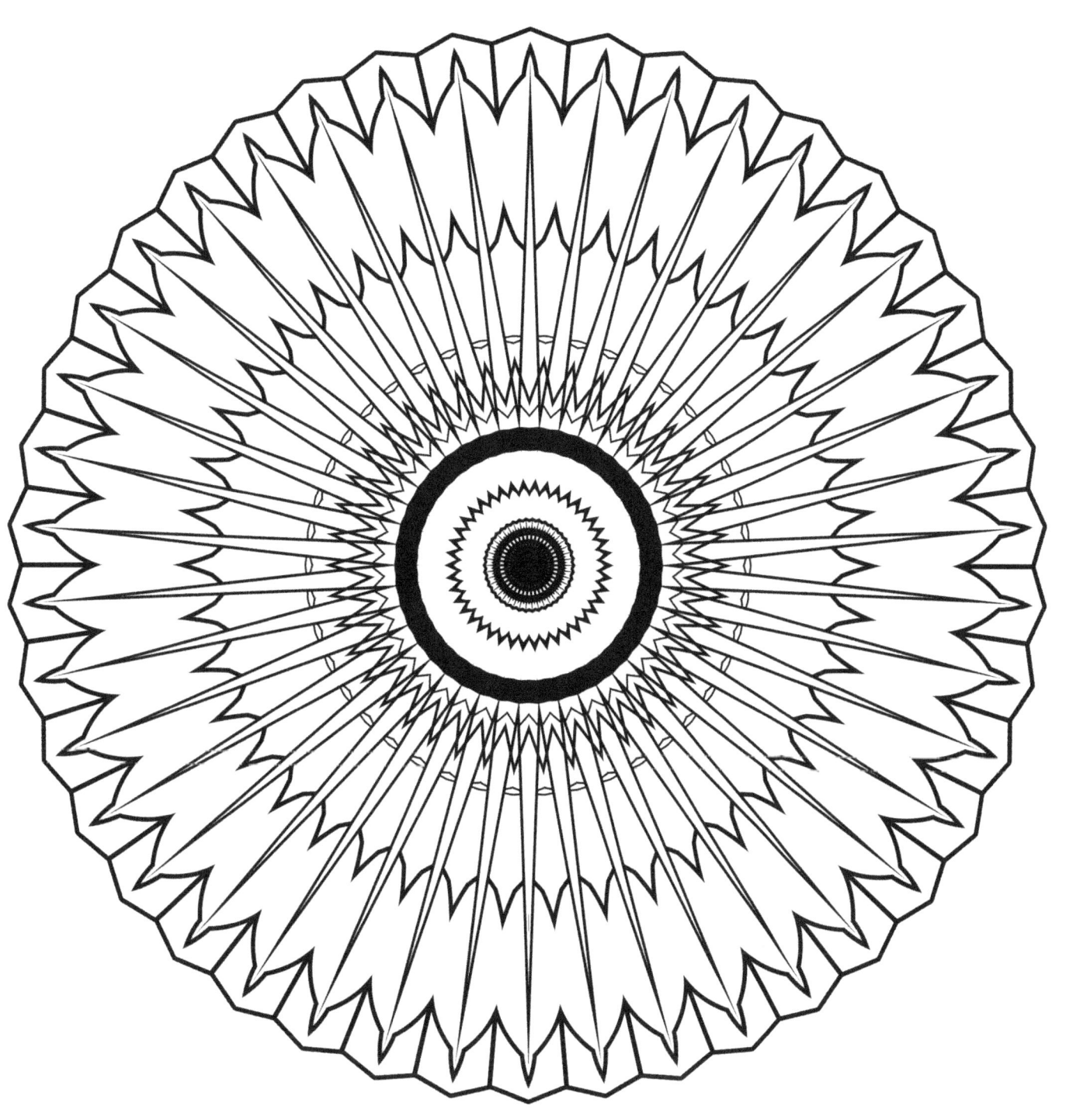

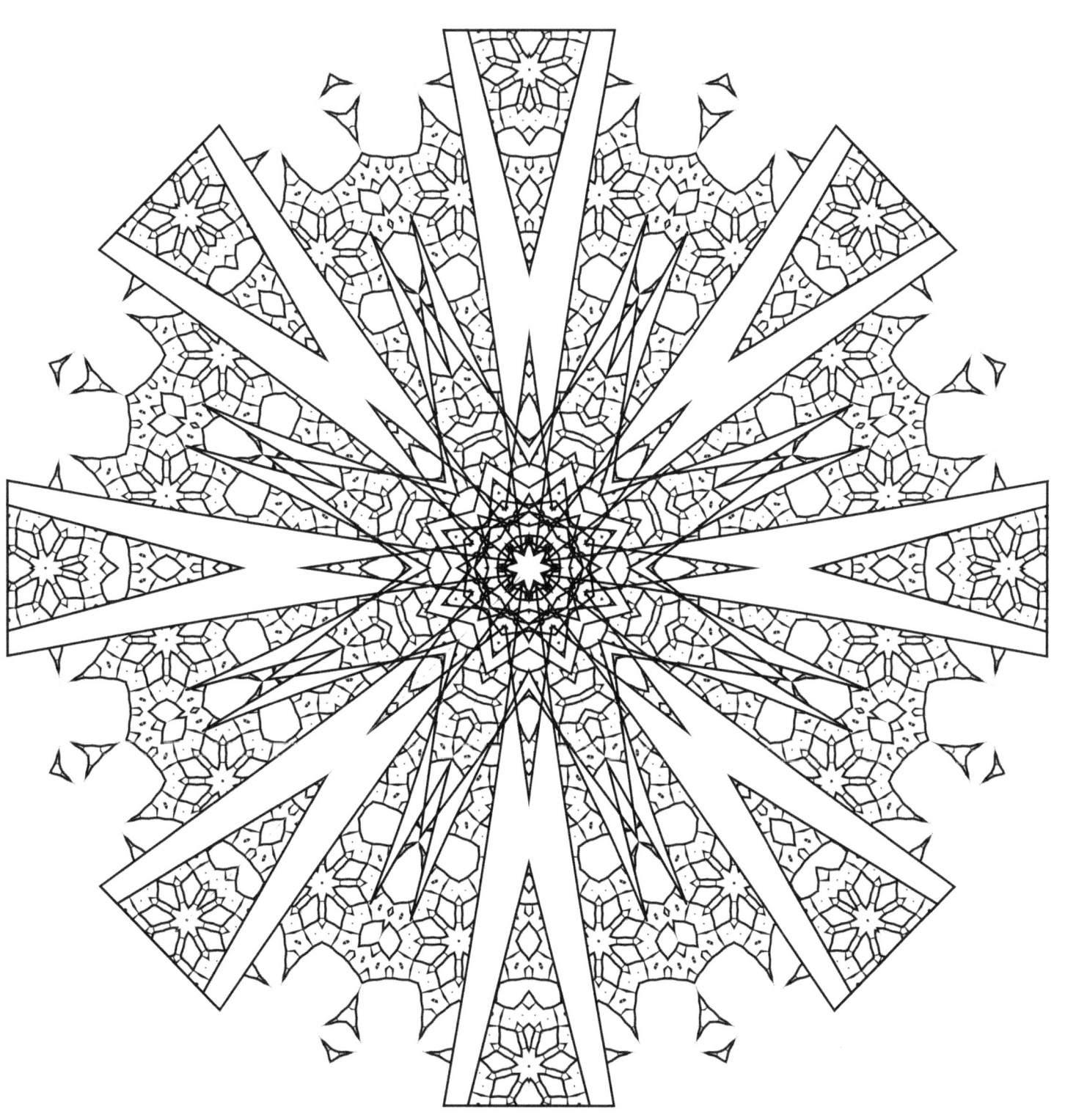

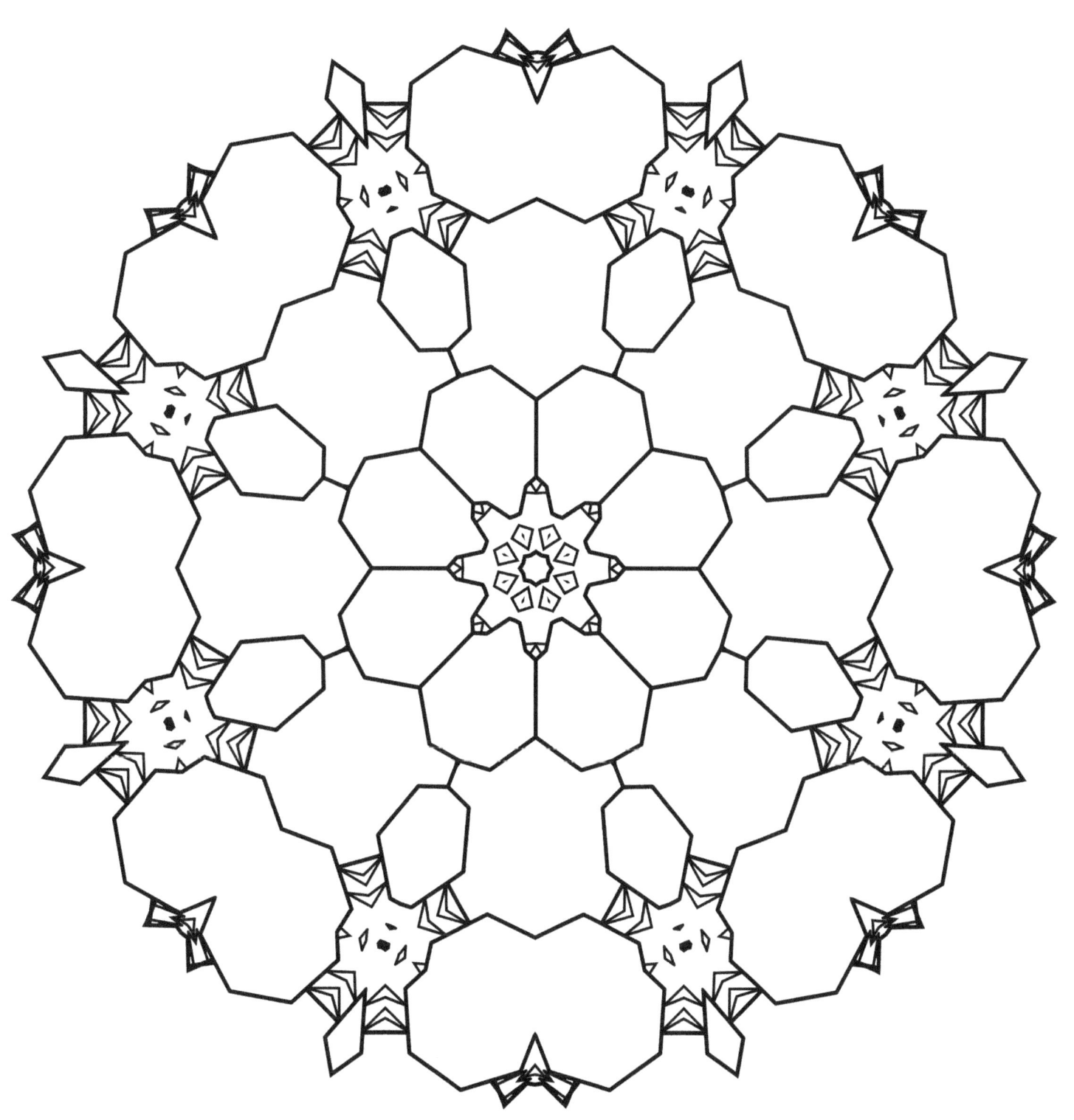

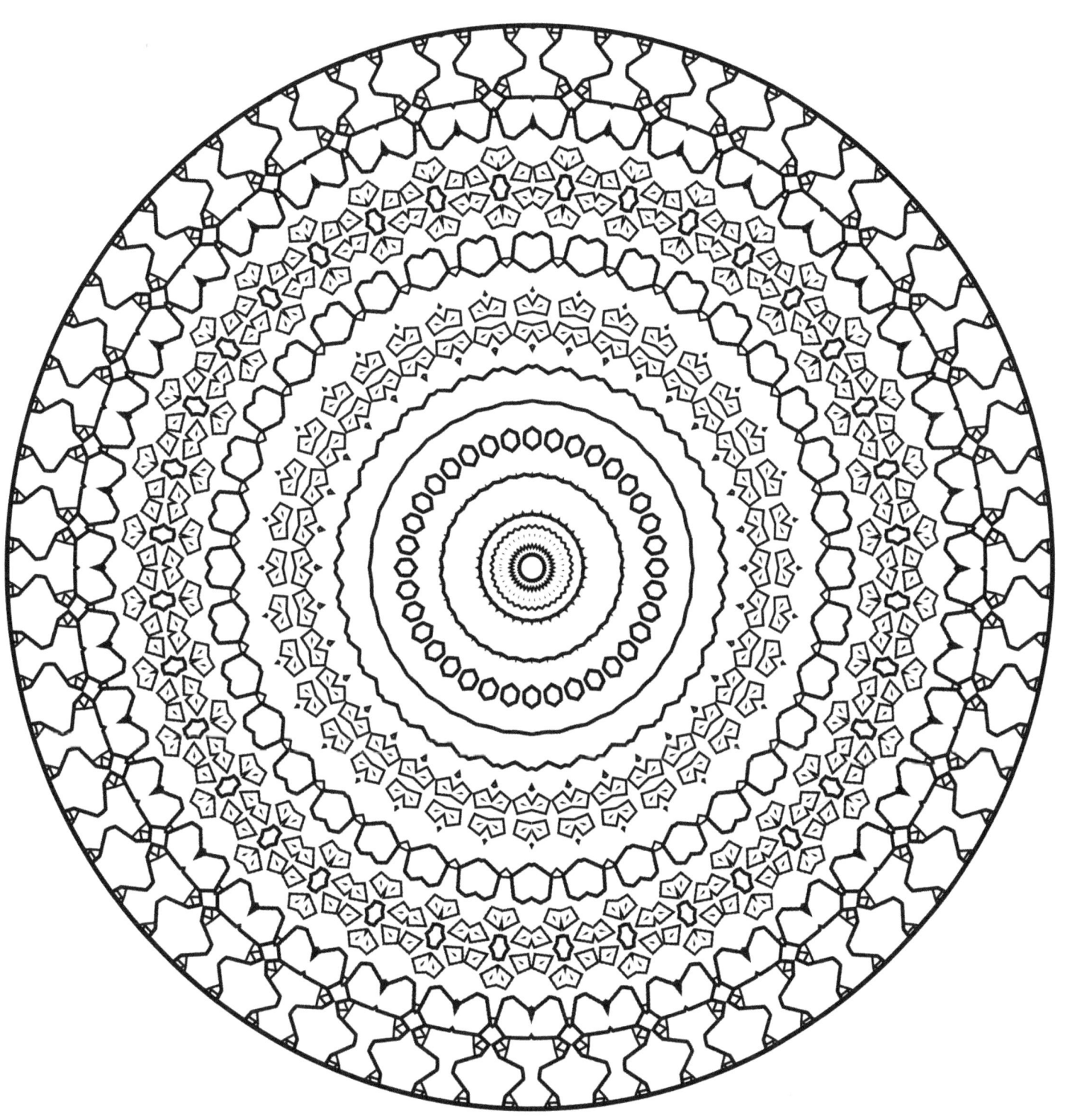

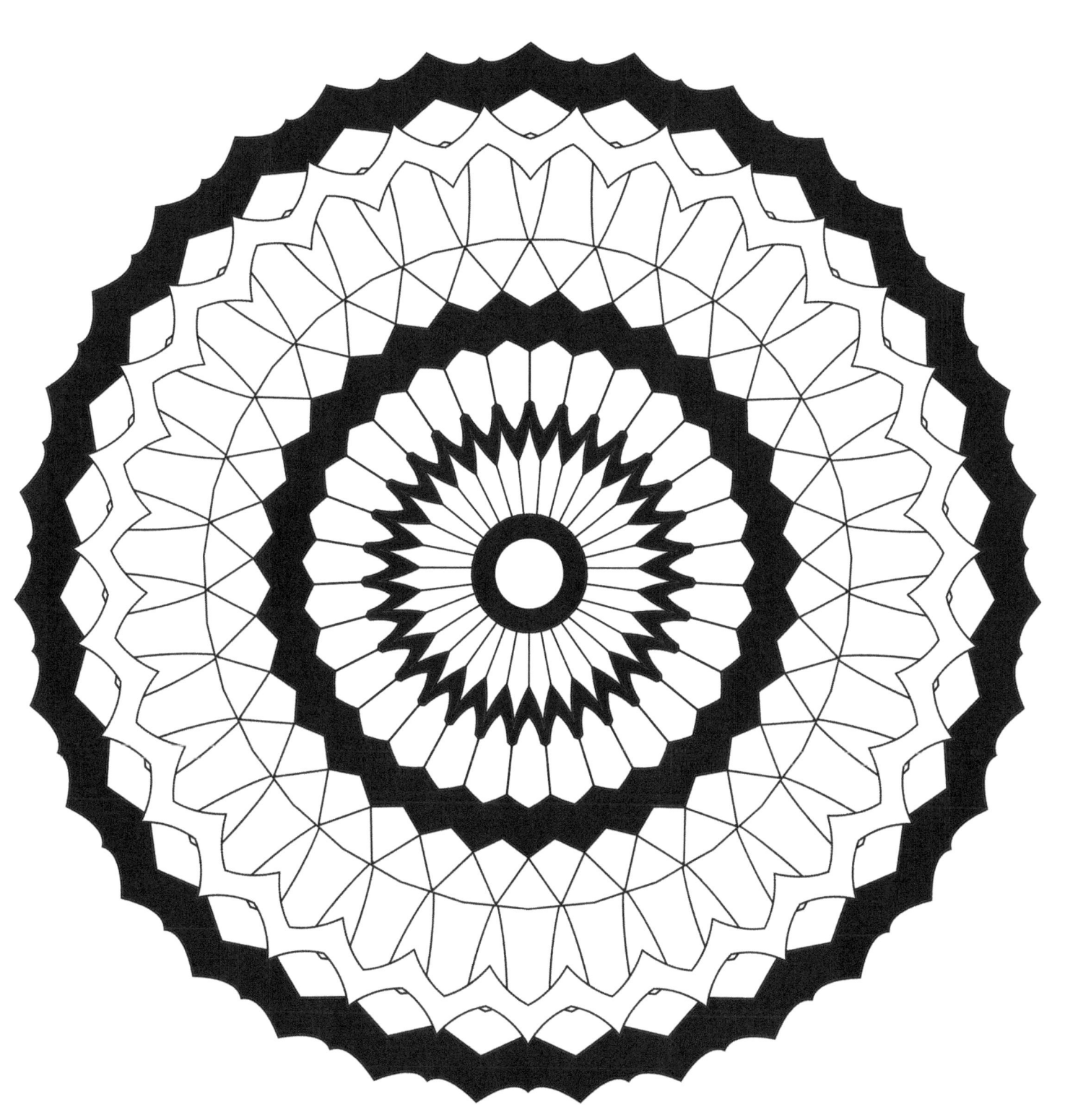

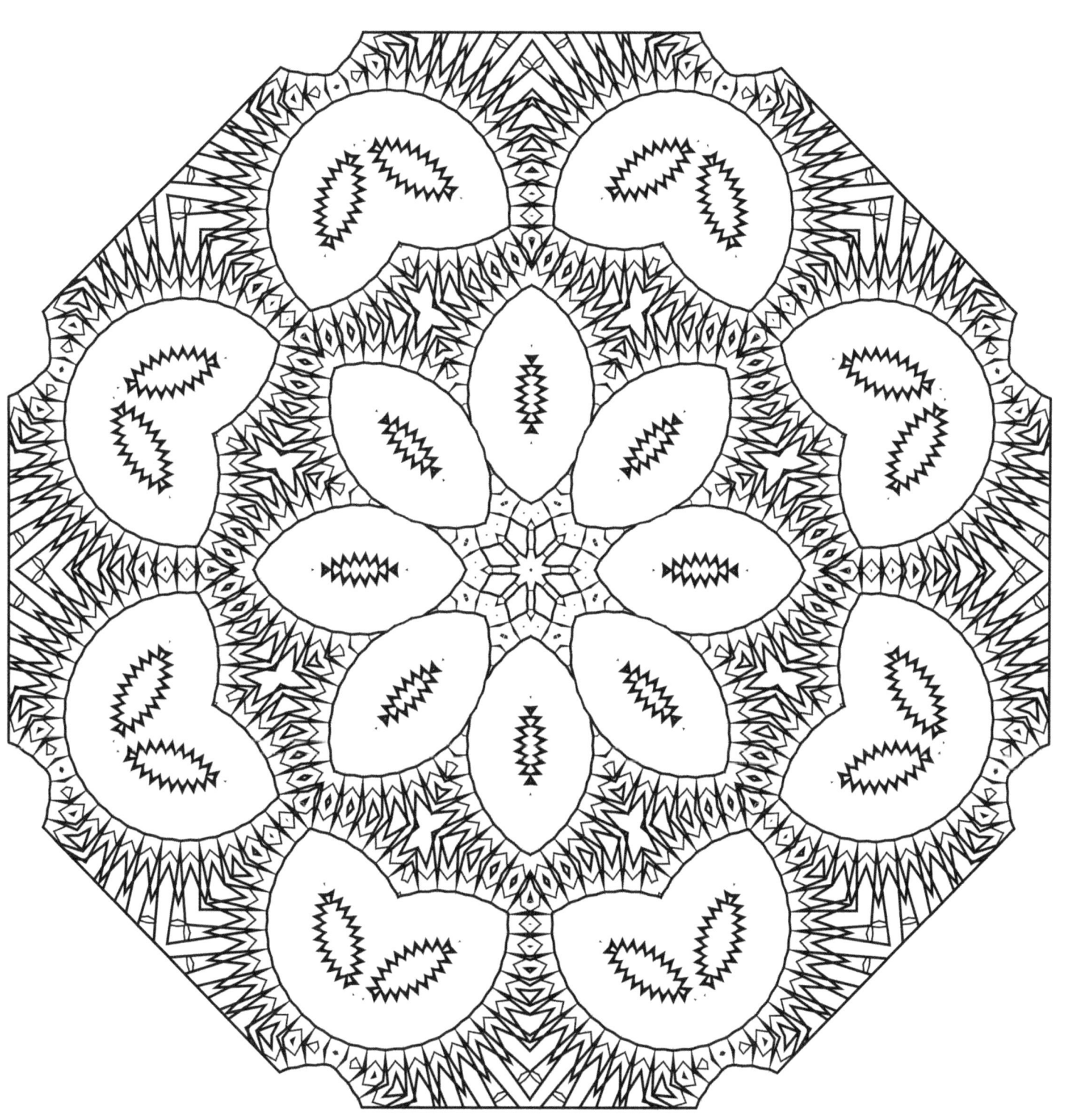

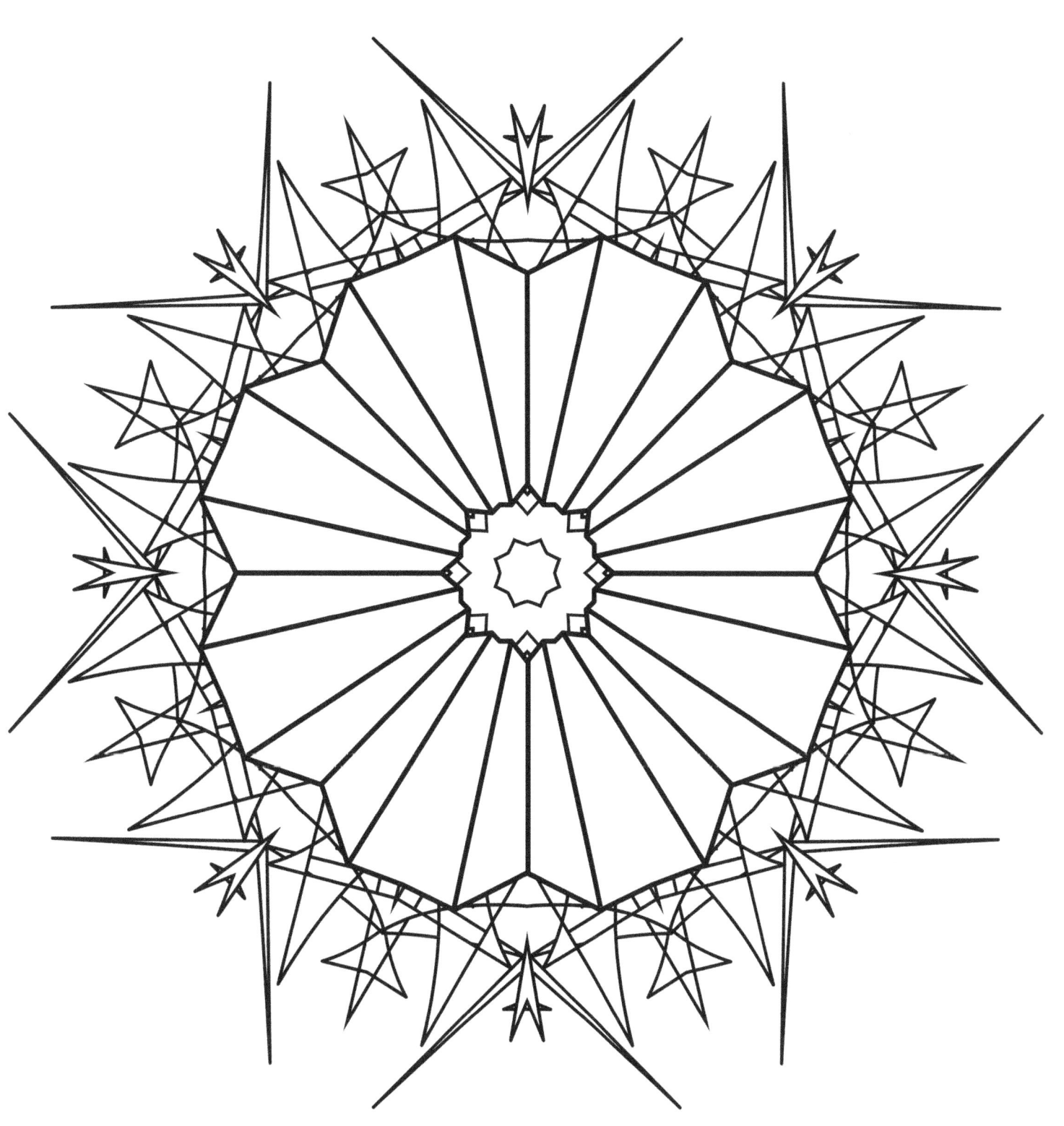

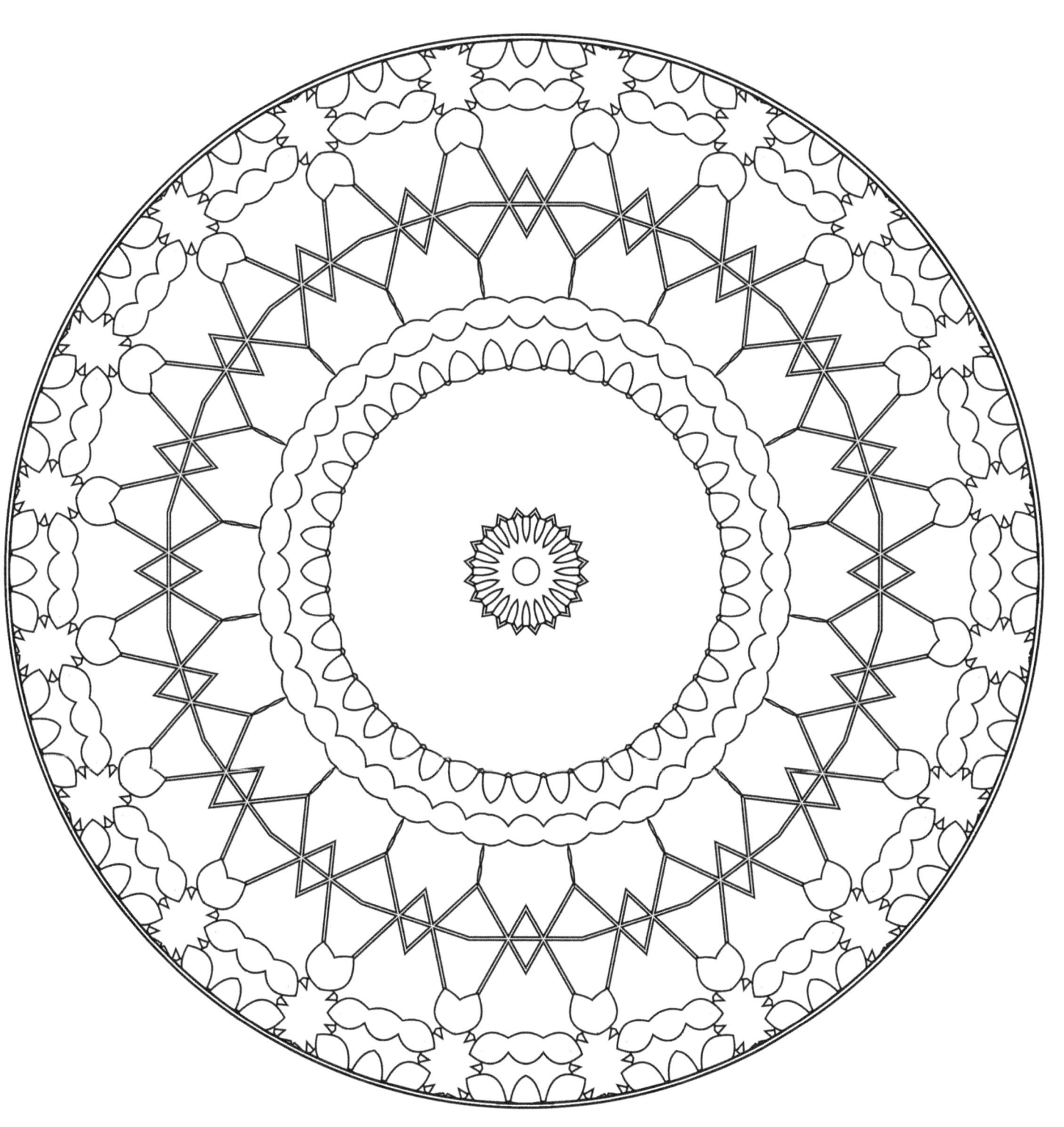

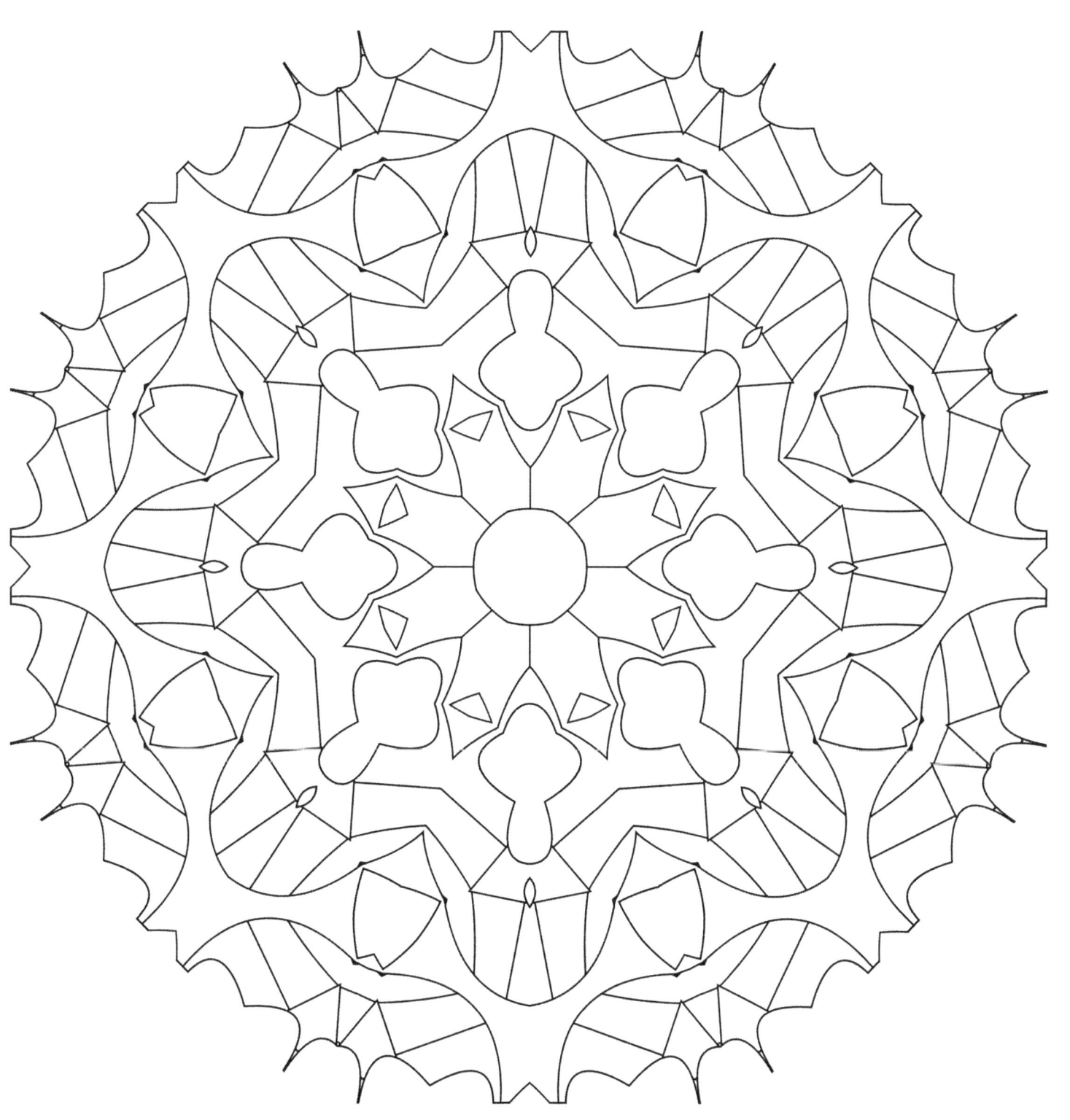

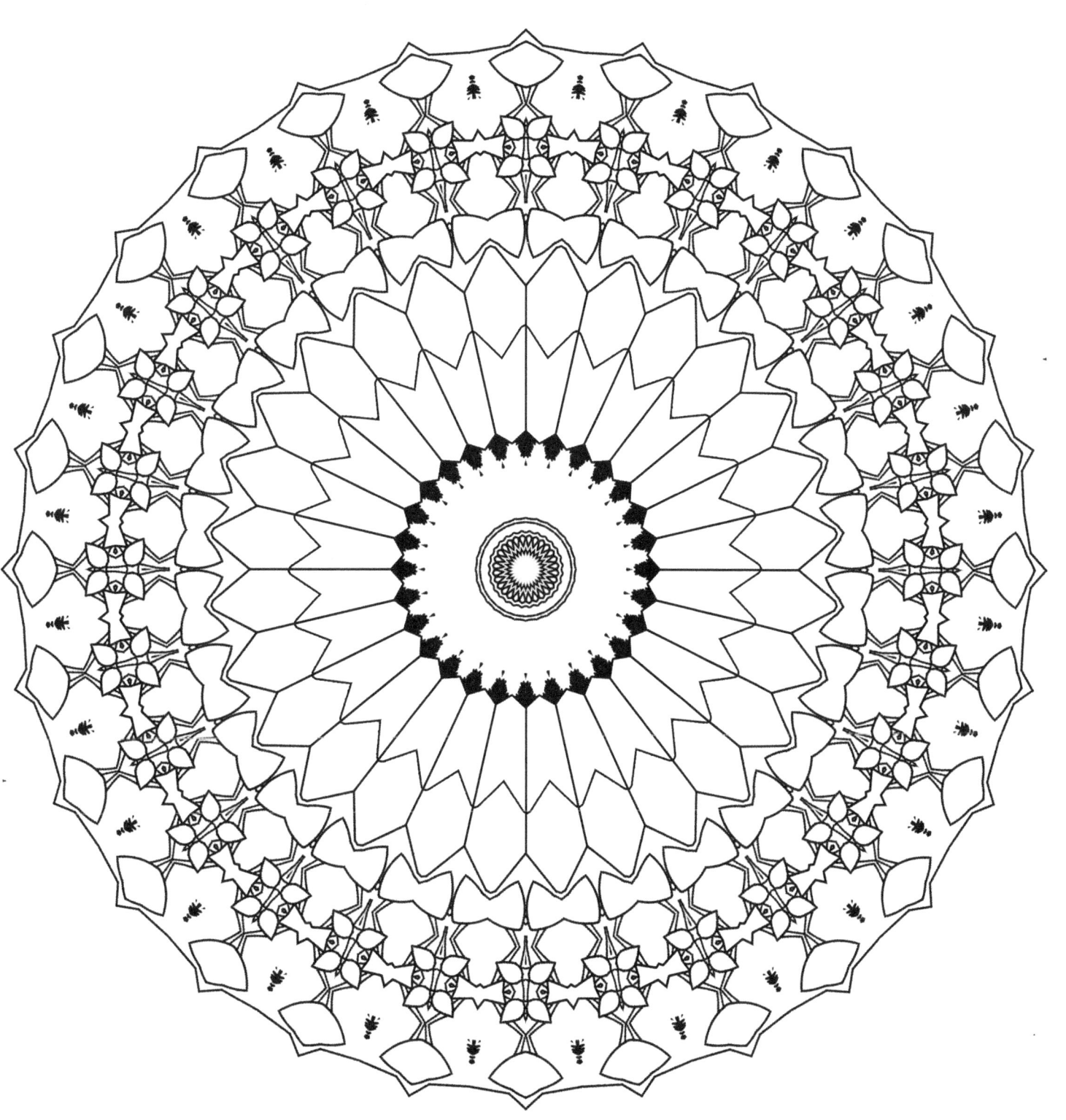

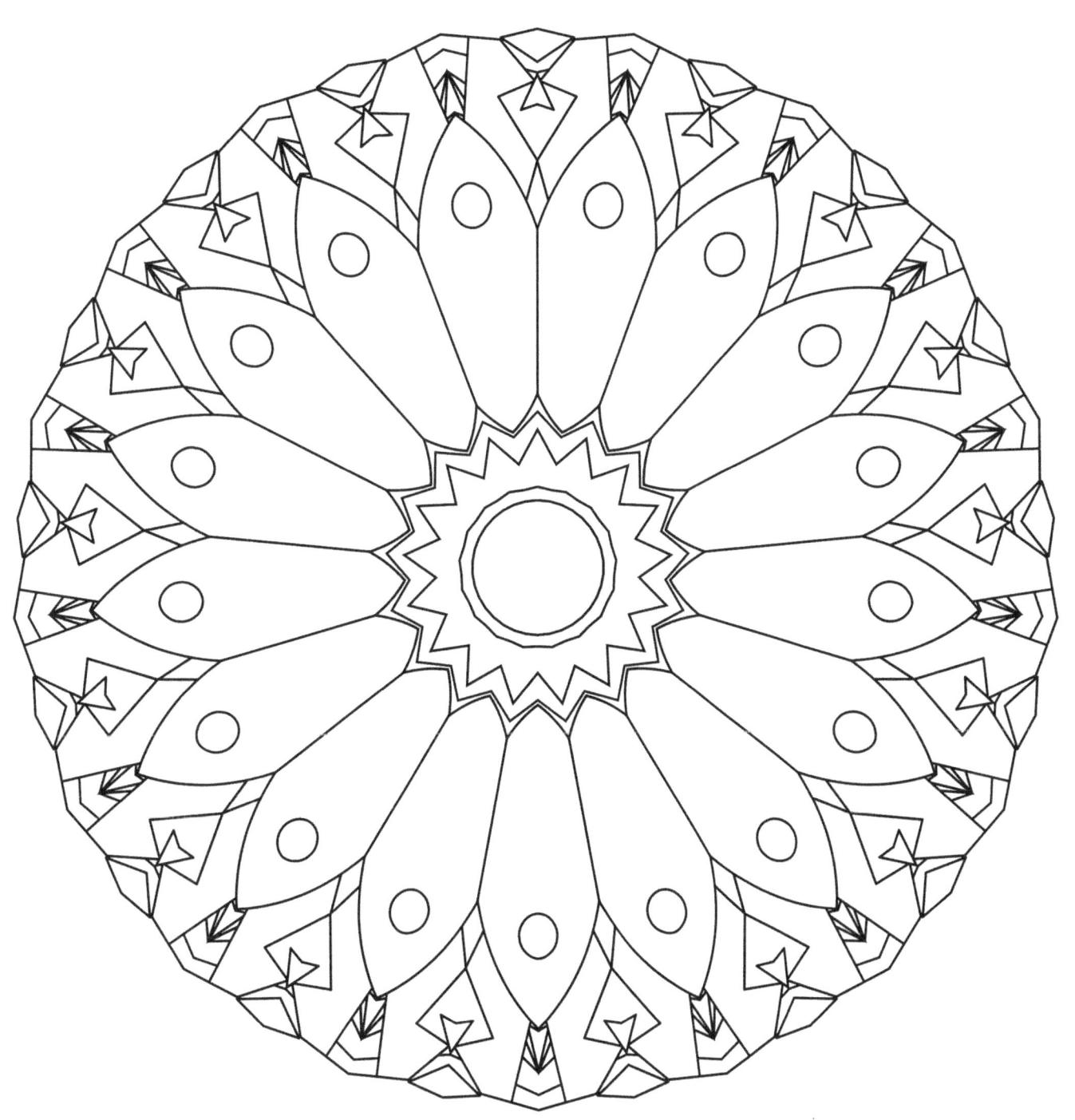

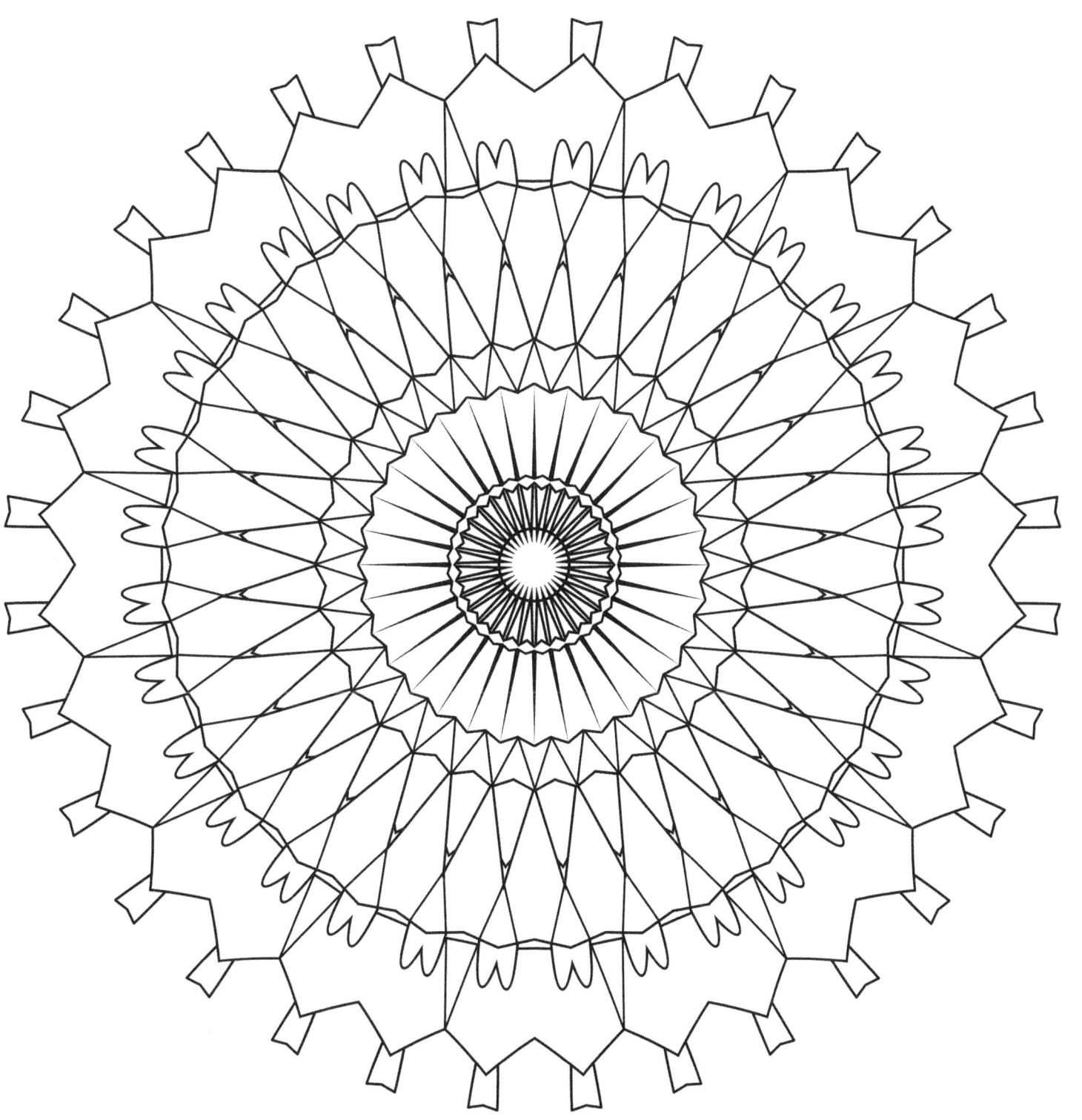

www.ingramcontent.com/pod-product-compliance
Lightning Source LLC
Chambersburg PA
CBHW080659190526
45169CB00006B/2191